BRISTOL

DANGER, DEATH AND DARK DEEDS

CYNTHIA STILES

AMBERLEY

ACKNOWLEDGEMENTS

As always, thanks to David and Sharon for their assistance in producing this book. Also to Andrew for his help. All modern photographs by Cynthia and Sharon Stiles unless otherwise indicated.

First published 2023

Amberley Publishing
The Hill, Stroud
Gloucestershire, GL5 4EP

www.amberley-books.com

British Library Cataloguing in Publication Data.
A catalogue record for this book is available from the British Library.

ISBN 978 1 3981 0534 8 (paperback)
ISBN 978 1 3981 0535 5 (ebook)

Typesetting by SJmagic DESIGN SERVICES, India.
Printed in Great Britain.

CONTENTS

INTRODUCTION

In any community like Bristol there have always been those who are intemperate, resentful, envious, greedy, angry, lovelorn, depressed or sadistic. Given certain circumstances these traits and emotions can drive even the least expected person to carry out criminal acts which may be calculated, long planned, opportunistic, seemingly inexplicable or even legal at the time. They are part of the dark history of Bristol.

Examining that history shows that Bristol was, for so many, a violent and dangerous place and there were great gulfs between the privileged and the poor. This book sets out to shed some light on a variety of murders and misdemeanours from the past, those who committed them and the conditions which may have brought such actions about.

RUN FOR YOUR LIFE

Looking at Bristol's twenty-first-century urban sprawl with so many modern buildings, it's hard to imagine the town in the Middle Ages, dominated by its castle and many churches. Places we consider central, like the cathedral and Broadmead, were outside the encompassing walls and the population was less than 10,000. It was a very stratified society governed by extreme rules. A large number were servants, bound to their masters and unable to change either occupation or status and generally the status of women was far down the line.

We know some of the crimes committed and who committed them, but not the reasons behind them. Perhaps you might make a guess that John the Fatte, who 'thrust William Wellop into a cauldron of boiling water so that he was scalded and died at once', could have been a cook who had suffered being taunted about his size just once too often. Alice, the wife of Peter Crossbowman, who cut her son's throat and threw him in a cesspool, might have been suffering from postnatal depression. There is a tantalising mention of Henry de Fynet, a woad

Alice, wife of Peter the Crossbowman, claimed sanctuary in the church of St Peter, now a blitzed ruin in Castle Park.

seller, coming after curfew to the house of John of Bruges, taking goods to the value of forty shillings and abducting Clarice, John's wife. John, although making a complaint, refused to say anything about the circumstances behind it to the court and so was put in gaol whilst Henry went free, but nothing is told of what happened to Clarice.

Few stories ended happily, though. Threat of the death penalty made many people run, sometimes even if they were not guilty, particularly if there were no actual witnesses. They would take to their heels and get to sanctuary in a church precincts, where they could not be pursued. The coroner would be called and the crime would be confessed to and a promise given to abjure the kingdom. Abjuration may have saved their life, but it was no light matter. It meant that this person was going out, shoeless and wearing just a coat for covering. They would be marked for all to see by carrying a wooden cross. The order was to travel straight to a port decided by the coroner and then leave their native country by the first ship available. During the year of 1491 it was stated that twelve people claimed sanctuary in the chapel of St Jordan on College Green.

The Priory of St James, across the river, was another popular choice for those seeking sanctuary.

Churches did come into conflict with the local authorities over sanctuary given to felons. The constable of Bristol Castle in 1279 was Peter de la Mere and he took umbrage at the fact that William de Lay, who had been imprisoned in the castle on more than one occasion, had escaped this time and reached St Philip and Jacob Church, thus avoiding a trial. So Peter sent some of his men, who stormed over to the church grounds and dragged William back to the castle where Adam de Steor, the prison keeper, beheaded him.

There was an outcry that such an infringement of church privilege had been committed. The bishop ordered punishment of these offenders. He commanded the men to walk in just their breeches and shirts on market days for four weeks from the Friars' Church in Lewins Mead to St Philip and Jacob, being whipped as they went. Apparently they later were offered the opportunity to instead go on crusade or even pay for someone else to do so. Peter himself, being of a higher status, was fined an amount to cover the erection of a stone cross near Old Market and the provision of food there for a hundred poor people on a specific day each year, when a priest would say masses for his soul. Whatever crimes he may have committed in life, it was reported that William de Lay gained a posthumous reputation as a martyr.

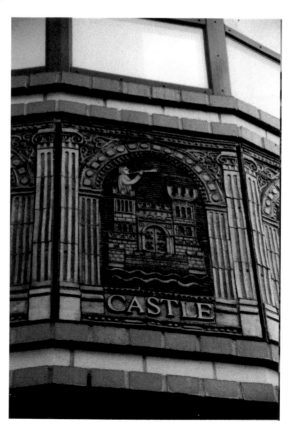

This depiction of Bristol Castle decorates a building on the corner of Host Street and is based on the first known seal of the City of Bristol, from the time of Edward I.

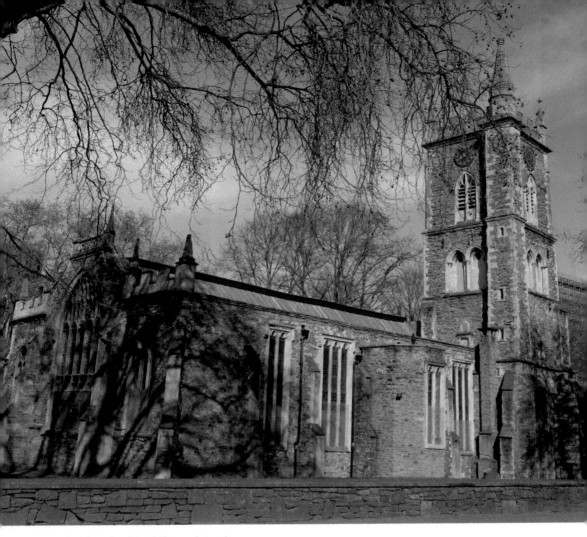

The church of St Philip and Jacob.

If you ran as far away as possible out of the town, rather than claiming sanctuary, things were even worse. In that case you may have temporarily saved your skin but were declared an outlaw, which meant you had absolutely no rights at all. Not only were your goods and chattels seized, but even your right to life was forfeited. If someone killed you, they would not be held accountable in law. If a woman ran away, she wasn't declared an outlaw, but she was denied the normal rights of protection generally afforded to women.

Even lords of the realm were subject to stringent treatment by the king. Around the beginning of the fourteenth century Thomas of Berkeley and his son Maurice, whose lands included Redcliff, had an acrimonious relationship with the Bristol burgesses. Berkeley's men attacked Bristol men who ventured over the Somerset side of the river to attend fairs, for example. On one horrific occasion they set on a cheesemonger named Adam, breaking his legs 'so that the marrow came out of

his shin bones'. Thomas and Maurice were slapped with a fine of 3,000 marks by King Edward I, a sizeable sum. However, the actual money was never collected on condition that the Berkeleys provided the king with ten armed horsemen and a captain to serve in Edward's war with Scotland.

The reign of Edward II was a time of great conflict between factions throughout the country. Edward had given the castle at Bristol to his favourite and adviser, Hugh Despenser the younger. In 1326 Edward's estranged Queen Isabella and her lover Roger Mortimer had brought an army into England, which soon gained support from those who disliked the king and the Despensers, father and son. The queen's army besieged Bristol, where the older Despenser was holding the castle, the king and Hugh the younger having speedily escaped by boat. The people of Bristol submitted to Isabella and in a grim public spectacle the old man, clad in his armour, was publicly hung, then beheaded, drawn and quartered and apparently fed to the dogs.

William Herbert was the son of Sir Richard Herbert of Ewyas, a gentleman, landowner, and once courtier to Henry VII. Young William thought himself a fine

Hugh Despenser the Elder's head was
sent to be displayed at Winchester.

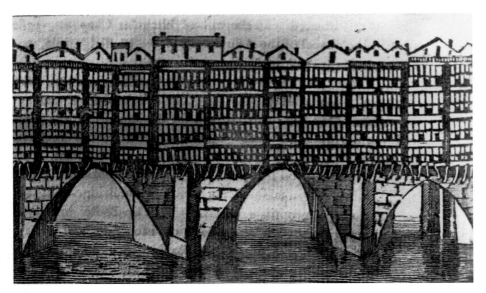

The old Bristol Bridge, setting of the fatal fight that meant flight from the country for William Herbert.

fellow. The tale of his encounter in 1527 with Richard Vaughan at Bristol Bridge has many versions. It has been described as a brawl, a bungled attempt to arrest the young man for rowdy behaviour, an altercation over precedence in a narrow spot, a past quarrel between the two families, both Welsh in origin, or simply the intimidation of an older man by a younger, boisterous one. Vaughan, said variously to be a mercer, a tailor, a clothier but in any case a man of some standing, who had been Sheriff of Bristol a decade before, came up against William Herbert with his companions on or near Bristol Bridge. There was violence and Vaughan was struck down, wounded in the head. Seeing Vaughan sprawled and badly injured, Herbert didn't bother with trying for sanctuary. It was straight into a boat and out of the country as fast as possible.

Herbert made for France. Vaughan died from the wound and his wife tried to get his killer arrested but it was in vain, as he was far away. Herbert was a brilliant swordsman, although a hot-headed one, and soon made a name for himself as a soldier in the service of the French King Francis. Then in 1528 came the news of a pardon, granted by Henry VIII. It is said that Henry had heard of William's proficiency and was keen to add him to his own household, rather than let him serve a foreign king and rival. So William was able to return and indeed was the king's brother-in-law when his wife's sister, Catherine Parr, became Henry's wife. He was created Earl of Pembroke in 1551 by Henry's Protestant son Edward VI, not only managing to survive the violent change of Catholic Mary's reign and serve her, but also scraping through to still be a privy councillor to Elizabeth for some years afterwards. One case where running for your life did pay off.

MISDEEDS ON THE KING'S HIGHWAY

Jack Shrimpton, a well-known early eighteenth-century highwayman, died on the St Michael's Hill gallows in Bristol, although he was born many miles away in Buckinghamshire and carried out most of his crimes in the area between Oxford and London. Eventually life got a little too hot for him there and he made his way to the West Country. Visiting a brothel in Bristol one evening he became drunk and obstreperous and this noise drew the attention of the St James' watchman, who stepped in, demanding Jack accompany him to the watch house, not knowing who he was. On the way Jack drew a pistol and shot the man, then threw the weapon aside, hoping to escape. Unfortunately for him his action had been seen and, before he could run away, he had been pounced on by a passing group of men. They took him to a magistrate and from there he was committed to Newgate gaol and so met his end in Bristol in 1713.

The word highwayman often brings to mind a tall, masked figure clad in cape-shouldered greatcoat and well-polished boots, armed with a brace of pistols, sitting on a black horse, coolly demanding your money or your life, then galloping off after a merry quip and a gallant bow to the ladies. Often the reality on the roads leading into Bristol was much more grim. In 1740 two men dressed like soldiers rushed out of a field between Totterdown and Brislington and attacked Jonathan Jones, servant to Mr Battersbee of the Pithay. They knocked him off his horse and yelled at him to give up his money, then rifled his pockets. Finding he had only about nineteen pence, they stabbed and slashed him in a dozen places, even threatening to cut off his private parts, saying that was because they were disappointed he was such poor pickings. Jonathan already suffered from lameness and was unable to make any resistance but after he had been left on the ground he still managed to drag himself to Brislington, though losing a great deal of blood on the way.

In October 1777 two post chaises coming into Bristol were stopped and robbed on Totterdown while the next night the Birmingham coach going to the White Hart in Broad Street was also robbed by two footpads a mere couple of hundred yards from Stokes Croft turnpike gate. John Weeks of the Bush Tavern was expecting his own cross-country coach by that route and, when the news reached him, armed himself and a companion with pistols and made their way to the turnpike where they too were accosted by the men. There was an exchange of fire and the footpads fled towards Cotham. Here they came across a shoemaker named Blindham, going home to Broad Weir, and robbed him of his watch, then cutting across to the top of Park Street where they held up Mr Trevellian and his wife, making off with a gold watch, three guineas and some silver.

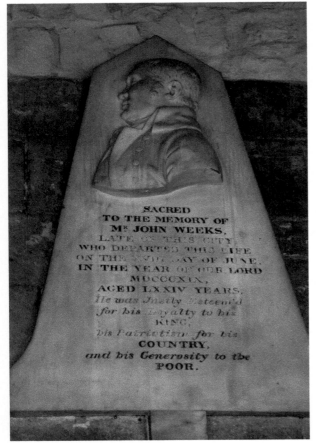

Above: Sketch showing the old road from Bath to Bristol, near Totterdown, early 1800s.

Left: Memorial to John Weeks in Bristol Cathedral.

Mr Weeks was held up at gunpoint again a decade later near the same Stokes Croft turnpike gate when returning to the city. This time there were three men dressed like sailors. They took the twenty-five shillings he had on him and his pocketbook. When he told them that it simply contained papers that were of use only to him, they returned the pocketbook and let him on his way.

Usually declared to be the last death caused by highwaymen in England, the attack on Richard Ruddle, Sir Robert Cann's coachman, in 1743 occurred as he was making his way back from Stokes Croft to Stoke House, his master's mansion on the other side of the Downs in Stoke Bishop. His murderers Burnett and Payne, ex-soldiers, were caught almost by chance a fortnight afterwards when a young man took a silver watch for repair into the shop of Mr Hewlett in Old Market. Mr Hewlett recognised it as he had repaired it once before and told the young man so. He claimed to have bought the watch from Burnett and took Mr Hewlett to Birch Lane, Lawford's Gate, where they confronted Burnett, who said he had got the watch from his sweetheart. This was found to be a lie. When they were about to be executed, Burnett and Payne said that they didn't intend to kill Ruddle but being a stout, resolute man he fought back and in the struggle a fatal blow had been struck.

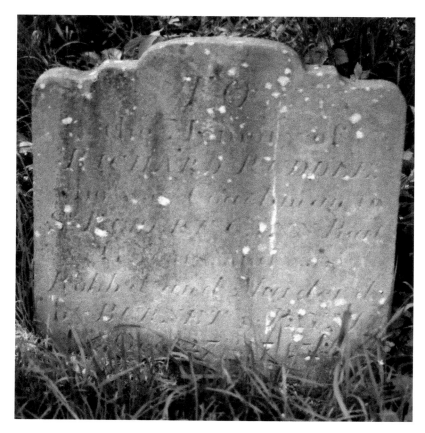

Gravestone of Richard Ruddle in the churchyard at Westbury on Trym.

It is said that nearly half a century later, Lady Catherine Lippincott, then the owner of Stoke House, travelled into Bristol by carriage to do some shopping. After visiting the bank, one place she called at was a draper's called Baker's in Clare Street and having chosen some goods paid from a purse in which she had a large sum of money. Then she made her way home towards Stoke House but on the Downs a man wearing a crepe mask rode in front of the carriage and, brandishing a pistol, ordered the coachman to stand and her ladyship to deliver her purse. So she handed her money over.

When the highwayman left the coachman said, 'Do you know who that was, my lady? It was Mr Baker, from the draper's shop.' She asked him if he was positive about the identification and, when he assured her he was, she ordered him to turn the carriage round, heading for Clare Street. Bustling into the draper's shop she demanded to see Mr Baker and was told he had left the premises shortly after her visit that afternoon but was expected back soon. So she waited.

In he came and looked worried to see her there but bowed and asked what else he could do for her. 'Give me back my purse', she stated, 'which you took from me on the Downs.' He replied that he had neither been on the Downs nor taken her purse but she told him her coachman was a vigilant man who was certain it was Mr Baker who had committed the act. If Baker handed back the purse immediately, she would say no more but any delay and she would report

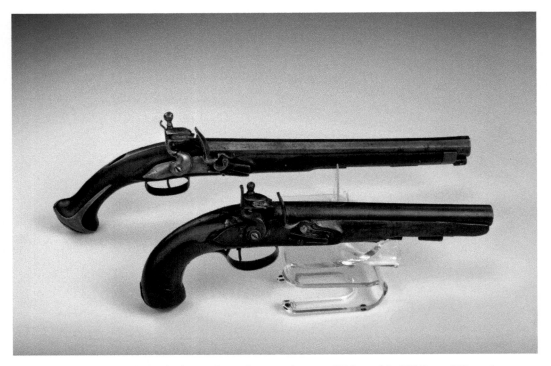

French and English flintlock pistols made around 1800. (W. Scott McGill © 123RF.com)

him. Baker gave in. Saying he was now ruined, he returned the purse and Lady Lippincott turned on her heel, re-entered her carriage and made her way back to Stoke Bishop.

Baker's shop closed that afternoon and did not reopen. No one knew where Baker had gone but it was said he was not seen in the city again. Eventually the story surfaced, it was believed from the coachman. Certainly no one heard a word of it from Lady Lippincott, so perhaps it was just a tale. However, crossing the Downs always had an element of danger and there were constant reports, at the time, of footpads in the area, sometimes lone predators, more often pairs or groups working together.

In 1752 John Jackson, sugar baker, and John Jones, a tiler and plasterer, attacked Mr Wasborough at the Claypits on the Downs. One caught hold of the horse's bridle and demanded money but the gentleman was not in the mood to be intimidated and hit out with his whip, striking the man on the side of his head, then tearing the reins loose, put spurs to his horse and with pistol balls whistling through his greatcoat, carried on along the road to town at a fine clip. He gave a description of the men, which corresponded with that given by the victim of a robbery the previous night and when John Jackson called at the Bell Inn in Broad Street a little later, saying he had come from Westbury and would like lodgings, Mr Thompson, the landlord, recognised him from Wasborough's description and made sure he was put in the kitchen under guard. Jackson denied being involved but Mr Wasborough pulled off the man's hat and pointed out the injury he had inflicted with his whip. Jackson and Jones were committed

The clay from this area of the Downs was used in making pottery. Now the area is covered with grass and trees.

to Bridewell, accused of several similar crimes in the area. They were executed on 23 April.

In 1764 crowds came to watch an execution on St Michael's Hill and an Irishman named John Jordan, who had been working as a barber at Bath for some months, turned highwayman. Hardly out of sight of the gallows, by the Downs, he held up and robbed in turn a chariot and two post chaises, one of which contained female relatives of Lord Westmoreland. Jordan was well-mounted and straight away rode for the New Passage, where he was waiting to cross over to South Wales when he was apprehended by his pursuers. Taken to Gloucester Gaol, he was hanged there, dressed in a clean ruffled shirt, though 'without coat or waistcoat'. At the gallows he said that indolence, drunkenness and the profanation of the Sabbath had been what made him fall into crime.

The Downs were once the haunt of footpads and highwaymen.

The Glen, an old quarry, one of several that were on the Downs. This one was not filled in and now contains the Spire Hospital.

From the beginning of the nineteenth century more houses were being built around the Downs and the area was now extolled as having beautiful scenery, rather than being bleak and dangerous. However, in June 1842 along came what was described as 'an organised gang of ruffians consisting of seven persons, three or four of whom are armed with large horse pistols', who were committing a series of highway robberies 'within even a single mile of this city, in the public road, and in the most daring manner', as the newspapers put it.

One of these robberies took place on the evening of Friday 17 June. Solicitor Francis Edwards had been to dinner at North Cote House, Westbury on Trym, and left at around 10.30 p.m. for his own home at Redland, about a mile away. Mr Edwards had not got further than 100 yards, opposite the Henleaze Lane turning, when he passed two men who eyed him up and down and then followed him. Then three other men jumped out of the hedge and they all closed in. One caught him by the collar, demanding money, while three others aimed horse pistols at his head. With such odds against him, he let his pockets be rifled. They pulled out his purse containing four sovereigns and sixteen shillings, and twisted off his gold watch from its guard chain, which one report stated 'nearly strangled him'.

After a few threats, the thieves went off in different directions, so he hurriedly returned to Mr Ricketts' house and reported the theft.

Of course the Downs were not alone in attracting villains preying on travellers. One night in March 1822 Mr Emerson, a watchmaker, was on his way home from work in Bristol to his house in Nags Head Hill, St George, and was near Moorfields when he saw what appeared to be an animal lying down in the roadway ahead of him. He was horrified to find it was a man with his arms tied behind, writhing in agony as his neckerchief had been twisted round a stick, turning it into a garotte. Mr Emerson managed to get him to an inn close by and sent for a doctor, so eventually the injured man was recovered enough to tell his story. He was John Ward, a carpenter on the way to Exeter from Staffordshire. Leaving Bath, he had been misdirected and so missed the coach and went into a pub for a drink as he was tired. Here two men and a woman started chatting to him and she said as he was going to Bristol, she could recommend some lodgings there for the night. When they reached Moorfields, however, he was set on by the men, who took his bundle, his watch and all his money from him, then left him so tied that he could not disentangle himself and would no doubt have strangled if Mr Emerson had not come along in time.

Viewed from what was the entrance to the driveway to Northcote, this is now a busy main road. The turning to Henleaze Lane is on the left-hand side, where the trees in the distance are. The lane became Henleaze Road and houses were built on what were fields.

A garotte – by inserting a stick into a knotted scarf and twisting, pressure on the neck is increased.

Around midnight on 9 May 1837, Eliza Fox and Elizabeth Bushell were returning from selling gingerbread and nuts at Shirehampton feast when, by the parkland, three men overtook them and began a brutal attack, demanding they hand over their money. When they refused, John Sheppard, the leader of this nasty little gang, knocked Elizabeth down and when Eliza called out 'Murder!' she was struck violently as well. Elizabeth was held down by two of the men while Sheppard tore off her pocket and robbed her of the four shillings in silver and a penknife/scissors tool which it contained. Things looked really bad for them but a gentleman named James Townsend was riding along the road and hastened to where he heard the screams, though he unfortunately arrived just too late to prevent Sheppard kicking Elizabeth on the jaw, fracturing it in two places.

Mr Townsend had a pistol and aimed at the robbers but they were three to his one and as he tried to take them into custody, they managed to escape. After hearing descriptions, Clifton police were able to arrest John Sheppard, particularly since he still had the distinctive penknife tool that had been taken from Elizabeth Bushell, who had to spend about two months in the Infirmary due to her injuries. Twenty-year-old Sheppard, John Gregory and Henry Williams, both at the age of seventeen, were subsequently tried for the crime at Gloucestershire Assizes, and although the younger two were acquitted as they could not be positively identified, Sheppard was transported for life.

Examples of the types of simple weapons used by footpads.

In November 1855 a musical young man named Roberts, staying on a visit with a relative at Knowle, went into Bristol to fetch two melodeons that he had sent to be repaired. As the repairs had not been straightforward, he was not able to make his way back until 9 p.m. The quickest way would have been across the fields but as it was a dark night he thought it would be safer to go round by the turnpike. He passed through Totterdown tollgate and was going down a lane when he saw two men sitting on a stile. He wished them good evening, but they made no reply. Suddenly he felt a blow from a bludgeon on the back of his head, which sent him sprawling. One knelt on him, making death threats if he was to shout out and beating his head against the road, took his watch and all his money and the melodeons. The two picked him up by the shoulders and legs and tossed him into a nearby pond. He pulled himself to the bank and tottered along till he reached his relative's house but though people searched, they found no sign of the attackers and his melodeons were lost to him for ever.

When travelling on foot along these deserted stretches of road, it was always comforting to have a trusted companion. Mr Sions, a hatter of Castle Street who was returning to the city past Filton on a December evening, was accompanied by his bull terrier. When he was set upon by a footpad who said not a word but just attempted to throw him to the ground the dog attacked, first sinking his teeth into the assailant's thigh and later getting him by the throat while Mr Sions escaped.

SPIRITED OFF TO SEA

By the beginning of the eighteenth century the increasing size of the British Royal Navy gave it command over the high seas. However, there was no permanent body of non-commissioned naval personnel to match the number of ships. It was considered far too expensive to keep so many men permanently provisioned and ready for when action was needed. When trouble brewed it was necessary to provide crews at short notice and led to the activities of the press gangs, a legal kidnap of thousands of men to serve in the warships.

Although theoretically any man between the ages of eighteen and fifty-five could be 'encouraged' to join up to serve their country (gentlemen and apprentices exempt), impressment was aimed at those with seafaring or river-boat experience. These men were going to war and untrained landmen could be trouble in the confines of a fighting vessel. So the real targets of the press gangs were sailors who had served on merchant ships and literally 'knew the ropes'.

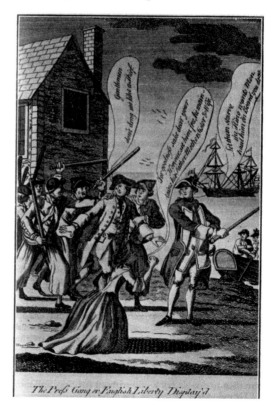

A press gang cartoon from an old broadsheet.

The Corporation of Bristol did have an interest in making sure that men were provided for naval service in wartime to protect the ships of its citizens. On at least one occasion the mayor offered an incentive to drum up adequate numbers by adding extra payment to the bounty that willing volunteers received. On the other hand, the merchants were opposed to their sailors being carried off by the press gangs. By the time of the Napoleonic Wars the passing of the Quota Act meant that each county had a legal requirement to supply a certain number of volunteers, according to population and maritime trade. As a result many a criminal was sent off to the Navy, instead of serving a prison sentence.

An article in *Cobbett's Political Register* in 1803 declared that a sailor's pay was nearly as good on a naval vessel as on a merchantman plus there was a fair chance of prize money when an enemy ship was taken. It was stated that the possible danger from powder and ball was less than from wrecks and accidents to merchant vessels and, should a man be disabled from this service, his king and country would provide him with an 'honourable and comfortable maintenance for the rest of his days'. There was no consideration by the writer, however, of the fact that the naval crews had no fixed length of service and could be away from their home and family for years.

Attempts to impress men could be violent affairs. On 8 May 1759 a group of five press gangers led by Cornelius Harris set out to take in some seamen from a privateer who had hidden out in an Ashton public house. He may not have known that there were thirty of them and how well armed they were. Seeing the odds stacked against them, the press gang tried to beat a hasty retreat but Harris was captured by the sailors who attacked him with their cutlasses, savagely slicing at his body, arms and head, fracturing his skull and chopping off some of his fingers. After kicking and stamping on him, they dumped him on the road. Although he was found and a surgeon sent for, he died a few days later leaving his widow, Sarah, to bring up their four children.

The day after this rout, the press gang got word that five of the sailors involved in the attack were in a public house in Marsh Street, which was quickly surrounded. Making their escape on to the roof, the seamen this time used guns. Returning their fire, one of the press gang wounded the landlady. The sailors seemed to be equally bad shots as they killed one of their own group. After this they surrendered.

Sometimes there would be mob action to free men who had been impressed. In 1803, after a successful haul of 200, the press gang, plus a party of marines, were escorting some of the men down Hotwell Road so they could be put aboard a boat to take them to the *Ceres* frigate. A crowd gathered, armed with bludgeons, shouting, swearing, splattering the escort with mud and muck, then hurling stones and broken bottles. The officers in charge ordered them to stop and get away to their homes but in vain. It was too much for three of the marines and they fired at their tormentors. One shot struck and killed a child, Mary Phillips received a wound in the breast and James Clement was wounded near the ankle

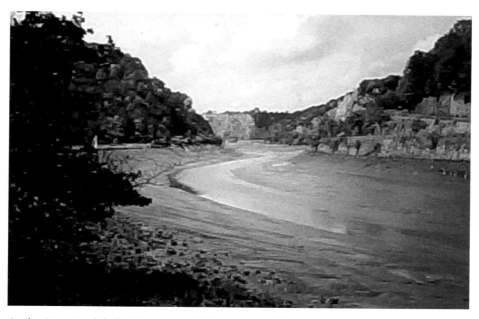

As the Avon is tidal, the river at the ebb is a mere trickle. Ships transporting pressed men to Plymouth and other naval ports would anchor nearer the mouth of the river, meaning that groups were marched down to Hotwells or even further to board boats to carry them downriver. This left the escorts open to hostile action from local people and sadly led to some fatalities.

joint, fracturing his leg. At an inquest the boy's death was declared justifiable homicide and the marines were therefore discharged, free of blame.

Sailors ashore frequented public houses in areas near to the quays, not just for refreshment, but using them as lodging houses, so the press gang often targeted such places. If they had information that suitable men could be found in private houses or businesses, there was nothing to stop them from forcing their way into the premises. It became a popular move, however, to seize crews on incoming ships before they actually docked in Bristol.

In 1777, as ships from Jamaica had come into Hungroad, the anchorage 2 miles from the mouth of the Avon, Lieutenant Brice and his men, armed with a warrant and guns, went out in a tender. To escape being caught, several of the sailors belonging to the ships got into their rowing boats, and were making off for shore, so the press gang pursued and fired at them, killing James Reynolds, the bosun of the *Friendship* and wounding several others. About sixty of the sailors were actually impressed. At other times fatalities happened before any action had taken place. Three years later, Thomas Mills, coming in on the *Hope*, tried to evade the press gang by jumping overboard and swimming to shore, but the tide was against him and he drowned.

In 1813 a press gang from the *Enchantress* decided to target sailors on the *William Miles*, which was coming into Cumberland Basin from the West Indies with a heavy

Left: The Hole in the Wall's spy house was used to keep an eye out for the press gang.

Below: The *William Miles* was a three-masted barque, similar to the *Kaskelot*, seen here at Cumberland Basin, Bristol.

cargo of rum and sugar. The ship was all but inside the lock on an ebbing tide when the crew saw these men arriving to impress them and made a run for it, deserting the vessel entirely. A newspaper report commented on how the *William Miles* despite 'having successfully escaped the perils of the sea and the enemy', then suffered considerable damage due to stranding and bilging in the lock at her home port.

There were cases where impressed men managed to be released. Unfortunately for the majority the fact that they were the sole supporter of a family including aged parents was not considered a good excuse, neither was claiming intermittent illness or fear of heights, if they looked 'good stout men'. One who was successfully released was James Caton. Caton had been the captain of a ship for many years previously but had retired from the sea, carrying on business ashore. In July 1779 he was at the Exchange in Corn Street when a press gang, led by Lieutenant Lane, burst in and proceeded to carry him off, protesting, to the lock-up.

Captain Caton was in the Exchange when he was dragged off by Lieutenant Lane and his men.

Captain Hamilton, the regulating officer, prevented anyone from accessing the captain, despite requests from his friends, who were shocked at the violent way he had been taken. He was kept in miserable confinement 'in a nasty stinking room' with a chimney place full of rubbish, as he put it. In the evening he was hustled off to a navy boat at Kingroad. Once more he was not allowed any contact with his concerned friends, who had made several pleas to Captain Hamilton. Even when the mayor summoned a court of aldermen, which Hamilton attended, the regulating officer refused point blank to give Caton up. He said he had done no more than his duty. Two of Caton's friends went up to London and due to the influence of Edmund Burke, the Bristol MP, a letter from the Admiralty was obtained saying Caton should be freed.

Caton was not freed until the third day of his captivity and said that although some on the boat had been civil to him and tried to make him comfortable, he had nothing but dislike for Hamilton. He was sure that Hamilton had allowed himself to be prevailed upon by 'malignant and despicable' men. This was the time of the American Revolution and there were varying opinions in Bristol as to the way the colonists had been treated and the validity of their actions. Caton seems to have expressed some pro-American statements, which would not have endeared him to certain parties. This was the argument when he brought an action against Hamilton and Lane at the Guildhall, being awarded £150 damages and the costs of the suit.

Caton's release was obtained through the intervention of Edmund Burke MP, whose statue stands in the Centre, Bristol.

Sometimes men taken by the press gang attempted escape once they had been put aboard a ship. In February 1782 some sailors who had been impressed and put on the *Diomede* seized one of the small boats and made their escape. The officer on duty ordered them to return and fired at them, killing one, wounding another, while the other two escaped. Later that year the impressed men on board a navy tender in Kingroad started a fight with the press gang and, after a considerable conflict in which one man was killed and several wounded, they took to the tender's boats and forty or fifty of them got safely to shore.

It was not just being impressed into Navy service that Bristol sailors tried to avoid. Thomas Clarkson, the abolitionist, on seeking evidence against the slave trade in the 1780s, heard that one slave ship had been deserted by the crew on experiencing the cruelty and inhumanity practised by the captain. It was a brutal environment that permeated everything. Not only were sailors burned with hot pitch for seemingly petty transgressions but their mental health was affected. One surgeon's mate was recorded as attempting suicide. The thought of being in the crew of a ship transporting human beings to such a fate was more than men could take. Many were bribed with extra cash up front or made stupid with strong drink in order to get them aboard, where they suffered poor food as well as bad treatment. With Bristol ships engaged in the trade, however, there was often a lack of choice if families were to be fed. Gradually the number of Bristol ships involved decreased, though it was not until 1806 that Parliament agreed to abolish the trade.

At the Battle of Trafalgar it is estimated that over half the Royal Navy's 120,000 sailors were pressed men. In 1816, with the defeat of Napoleon, it was reported that the House of Lords were proposing a full investigation into the subject of impressment of seamen and several members of Parliament began indicating their total abhorrence of the practice. It wasn't a quick or easy process. Eventually, in 1835 by a couple of Acts, the process was amended so that the length of time of service was fixed at five years and when time expired the seaman was to be returned home in a naval ship. Without ongoing wars the use of impressment declined and in the 1840s a structured naval recruitment system had been set up. Ships were being filled without impressment, so there was no need to forcibly round up sailors off the streets of Bristol and other ports.

NOT SAFE IN THE STREETS

On a Sunday morning in 1785 Reverend Edward Bowles, a minor canon of Bristol Cathedral, was shot at in Christmas Street after conducting the service at St Nicholas' Church. A young Irishman named John Murray came up to the Reverend Bowles and pulled out a pistol. Holding it in both hands, Murray aimed it at the clergyman's chest and fired. There was a flash but as the weapon had been overloaded with powder, it exploded in Murray's hands, tearing his flesh. The bullet had therefore luckily lost so much of its force that it barely penetrated Bowles' clothing, though thoroughly alarming him and his female companion. All sorts of speculation ran rife. Was it possible that Murray been hired to kill Bowles and if so, by whom and why? There were Bowles families in Ireland, after all.

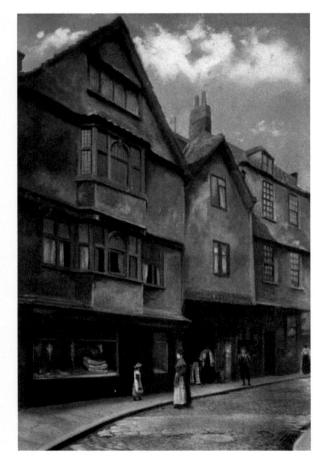

These three ancient buildings were all that remained of Christmas Street after the widening of Rupert Street in the 1960s.

The next day, his hands well bandaged, Murray was taken to the Council House to be questioned. He was twenty-five years old and came from Kilkenny, a tailor by trade, though he had been three years in the Army, being discharged six months previously. Since then he had worked in London and had only bought the pistol in Windsor last week, when he had made his way to Bristol. He claimed that Bowles was a total stranger to him and it was the devil's voice in his head that had made him carry out the act. He was convicted at the Sessions and sentenced to be hung.

In October 1791 Margaret Brown and Mary Plumley, coming across Brandon Hill, suffered assaults by a man with a knife while another woman, Mary Bullock, was attacked while returning from Limekiln Dock to her home in the Horsefair. In the Ropewalk by Canon's Marsh she was approached by a man, who stabbed at her side. However, her stays deflected the blade, so she escaped serious harm, but he then threw her to the ground. While she lay there, winded, another man appeared, calling 'Do for her' and giving her a kick. She called out desperately for help and she was saved by a black man who heard and came along to her aid, her assailants running away.

A few days after, Sarah Radford, nursery maid to a surgeon's family, was walking in Dove Street, Kingsdown, carrying one of the children, when she also encountered a man with a knife, but his attack too was ineffectual, though

A route across Brandon Hill.

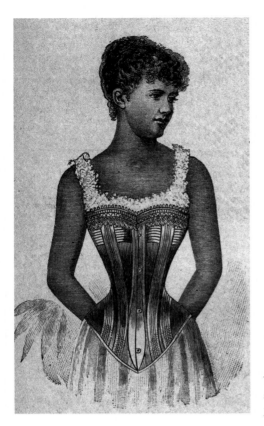

Women's undergarments like stiff linen stays or later heavily boned corsets could prevent serious knife wounds.

frightening. In 1804 there were reports of more ruffians wounding women at night, 'so that no female will venture into the streets after daylight'. One woman died from the cuts inflicted on her body when she was crossing St Mary Redcliffe churchyard while others shortly after were severely injured. A reward of three guineas was offered and this time six men were imprisoned for the crimes.

At the beginning of the nineteenth century Bristol was not only poorly lit, with areas of unfenced quayside, but the streets were narrow with many old timber houses. Like other towns and cities it became more crowded as people moved from the countryside into urban centres. It was noted in the newspapers at the end of the Napoleonic Wars that so many of the thousands of returning soldiers and sailors, now to be cast jobless into the community, had been convicted felons given the opportunity of military service rather than languishing in prison. Their homes were in a tangle of courts and alleys that lay behind entrances sometimes only wide enough to allow grown men in single file.

The alleys coming away from the old centre of the city were often steep and twisting. Zed Alley, a very ancient right of way, was originally more winding. In 1859 William James Butler, stationer of Baldwin Street, was found mysteriously

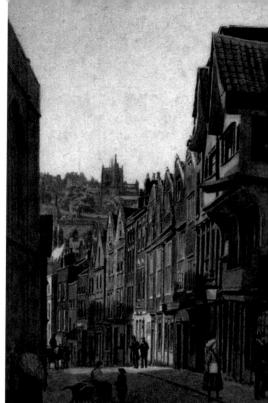

Above left: St Mary Redcliffe churchyard.

Above right: Small Street was only 9 feet wide at one end. It was widened gradually with the construction of the General Post Office building and later removal of old houses at the beginning of the twentieth century.

dead on the alley steps with a broken neck. People were pretty sure he had been attacked and murdered but the coroner could not find definite evidence.

One of the reasons why the Arcades were so popular, when first built in the 1820s, was that they offered an alternative to such 'miserable defiles' as Sims Alley, running from Broadmead to St James Barton. The Arcades not only gave a covered way for shopping but there were several porters who had 'strict directions' to take into custody those who were annoying and insulting the people using these passages.

In early 1821, as an example, there were many reports of street robberies. Mr Cook of Bridewell Lane was robbed by three men at the entrance to St James' churchyard. Mr Capper was walking down Union Street when Andrew Haslaw rushed against him, grabbed his watch and ran off with it. Mr Capper shouted 'Stop, thief!' and took up the pursuit. Someone tried to get in Haslaw's way to attempt to halt him but he whipped out a bludgeon to give a smart blow to the head. By now there was a full hue and cry and the thief made for Lewin's Mead, casting aside the watch but in vain, for he was caught and taken into custody. Mr Shearer, who was attacked near the Lamb Inn, West Street, by two ruffians, one of whom aimed at his

Above left: There were also narrow pathways running between the main streets.

Above right: Zed Alley.

head with a bludgeon, had a nifty way to deal with that. By parrying the blow with the umbrella he had in his hand, he managed to stop it from cracking his skull and the men ran away. Such crimes carried a high penalty at that time. Elizabeth Bissix, Susannah Robins and Mary Williams, charged with assaulting Ellen Franklyn and stealing her cloak and bonnet, received the death sentence in April of that year.

The street didn't have to be narrow and dark for danger to strike. On an April evening in 1851 Nathaniel Meech, captain of the Jersey packet the *Dapper*, was walking through Broadmead, described as 'one of the widest and most frequented thoroughfares in the city', when he was surrounded by three young men. Henry Parker planted himself squarely in the captain's path while, from behind, two blows struck the victim's head, causing him to fall to the ground. They robbed him of his silver watch and chain and money but fortunately a lady came upon the scene and shouted out an alarm. This sent his attackers running away and the captain managed to get to the police station. Parker, being identified, was taken into custody. The other two, Joseph Reed and George Davis, escaped at the time but were picked up and identified by a witness who had seen them as they fled.

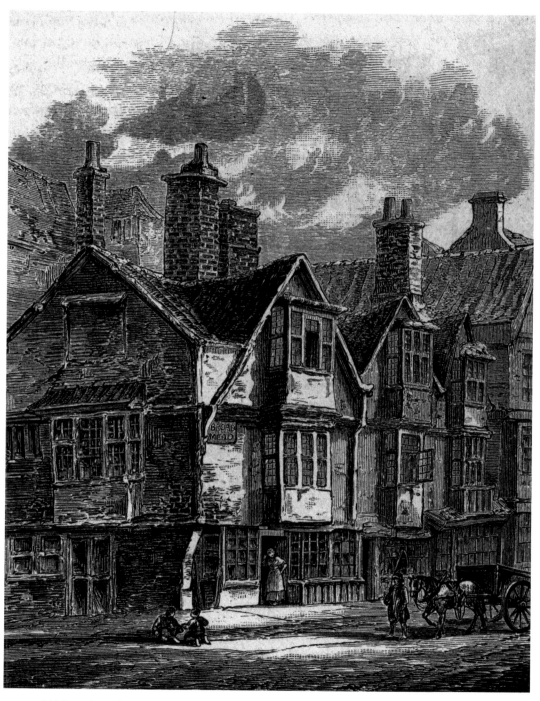

Old Broadmead.

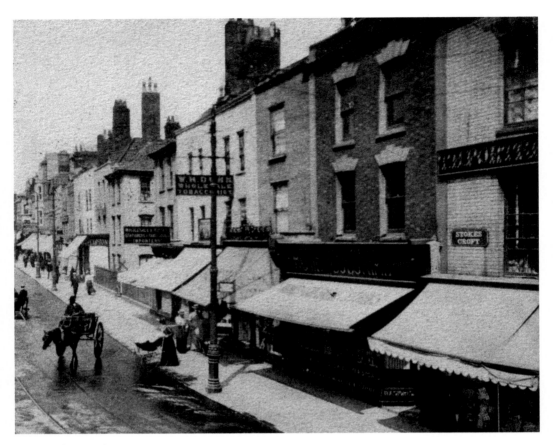

Stokes Croft.

In October of the same year, on a Thursday at 8 p.m., a female servant of Mr Perry's left his house in Catherine Place to get the change of a £5 note from the nearby grocer's shop at the top of Stokes Croft. She was returning home when a person came up behind, threw a thin rope across her throat, pulled her backwards, took the five sovereigns and left her gasping and terrified. Her throat was so painful that she could not raise the alarm and could hardly speak when she got home.

Robbery, of course, wasn't always carried out with force and threats of violence. It could be the result of cunning and sleight of hand. In November 1847 a group targeted Captain Dyer of the *African Queen*, who had been to Miles's Bank in Corn Street and put his money into his pocketbook. He was carrying about £80 in total. He then went in a silversmith's shop before crossing the road to take a cab at the corner of Marsh Street when he felt a hand in his pocket and quickly grabbed at an arm. It was that of a young man named Charles Phillips and the captain pushed him into a shop and reported him to the police. Although

Phillips was thoroughly searched no stolen property was found on him. Phillips, however, had been one of a sizeable group of young people milling about and the money could have been passed to any of them. In fact two of the women were later searched and found to have thirty-four sovereigns on them. The police and magistrates had previous encounters with Phillips, who had been in prison before on charges of theft. He was remanded in custody with a fellow member of his gang, Daniel Newton.

These groups of stylishly dressed, respectable-looking young men and women had gained the name of 'the swell mob', many coming originally from London and known to be deft pickpockets and adept at distraction crimes. In 1840, reporting a similar crime perpetrated in Bristol on a farmer from Glamorgan, the newspaper comment was 'Countrymen visiting our city should keep their wits about them. There are plenty of sharpers to be met with in our streets.' Phillips himself was described as intelligent looking and genteely dressed.

While waiting to be brought before the magistrates in December, Phillips attempted to escape from the Bridewell. Having broken the lock on his cell door, he got as far as the yard but the turnkey, hearing a noise, looked out, saw him and soon had him back behind bars. However, by the time he and Newton came to court again with their lawyers, Captain Dyer had had to sail for Africa so was not there to press the charge and Newton was discharged. Although Phillips had tried to escape, due to a legal technicality the magistrates were advised it would not be safe to commit him for trial at the Quarter Sessions. Just as Phillips was about to be discharged, in walked Captain Dyer, who had been forced back by adverse winds, so he was able to prosecute and Phillips was committed for trial. Fate was on his side though because by the time the Quarter Sessions came around, Captain Dyer had sailed once more, so there was no prosecutor and the case was dismissed.

Sailors of many nationalities came into the port and were often involved in fights around the Quay area, though generally amongst themselves. There were exceptions. Around 11 o'clock on a March evening in 1869, some Bristol porters and their friends crossing the drawbridge came across a group of foreign sailors singing at the corner of Clare Street, so they stopped and listened for a few minutes. Suddenly one of the sailors, Bernardini, an Italian, shouted 'Sacramento' and he and a number of his companions drew their knives and rushed at those who were watching, who scattered in terror. One of the porters named Drew was stabbed by two of the Italians, in the neck and back, while another porter, Sadler, was pursued in a different direction and stabbed in the nose. Bernardini, in defence, said that he had been with a group of his countrymen at a party in the Millwright's Arms and when they came out singing a crowd had gathered, mocking them, and tempers had boiled over. Bernardini and one of the other Italians were convicted at the Assizes but later granted a free pardon by the government.

The drawbridge leading to Broad Quay and Clare Street.

The old city of Bristol was gradually becoming encircled by suburbs with advertisements for 'Eligible building land, desirably situated' at places like Cotham New Road, described as 'less than a mile from the Exchange'. Here, from the early 1840s, were constructed villas, 'well and substantially built, fit for the reception of respectable families'. The head of one of these respectable families was Mr John Godwin of Auburn Villa, at the age of seventy-five in August 1851, when he went for a walk from his house past the grounds of Redland Court. Although it was broad daylight, he was attacked from behind by a powerful man, who grabbed him round the face, covering his eyes and mouth and then kicked him until he fell down. Once on the floor he was kicked in the head and passed out, seriously injured, while his gold watch, purse and loose money were taken.

Things could have ended even more badly had it not been for young James Collicot, who was delivering a parcel of boots made by his master to Redland Court. Having seen a man watching him, who then pretended to look in a hedge, Collicot, as he passed, stared hard at him so the man walked away a little. After he had completed his delivery, he got back near the gates when he heard groans and saw two people struggling in the road. He was sure that the man kicking the person on the floor in the head was the one he had seen earlier and he ran towards them, the assailant making off.

By Redland Court gates.

He helped Mr Godwin up, heard that he had been robbed and at once alerted some carpenters working on Redland Green, to see if they could catch up with the attacker, but he had successfully fled out of sight. Mr Godwin was carried to his house and the police were sent for. Collicot gave them a full description, which led to the later capture of John Williams, in an accident of fate.

A policeman from St Philips Division who was investigating counterfeit coins went into the Boar's Head beer shop in Lamb Street as a man was leaving. He seemed alarmed at seeing a policeman and ran into a courtyard behind the beer shop, climbed on to the roof of an outbuilding and from there scrambled across the rooftops of nearby houses. The policeman followed on the ground, ducking a loose tile thrown to discourage him. Eventually the man jumped down into another court, closely pursued by the policeman. There was no way out so the fugitive rushed into a house, tried to grab a poker, but stumbled over a chair and was taken prisoner. He fitted the description provided by Collicot and was subsequently identified by him in person. A heavily tattooed man, John Williams gave his occupation as a hawker, though it was thought that may have been a false name and he had been a sailor in the past. That was the name he was convicted under at the Assizes, where he was sentenced to transportation for life.

William Cannicott had been a perfumer and hairdresser in Broad Street but, in 1860, he was living at Horfield. On 15 October he had left home and went down to Easton and then Park Row, finally leaving central Bristol about 9 o'clock when he came up Stokes Croft with a friend. His friend was anxious to return home by then, so Mr Cannicott continued alone and arrived at the

Horfield Inn before 10 o'clock. Here he partook of several glasses of gin and water and eventually decided to leave around three hours later, by which time he was staggering a bit. He asked others in the inn if they would walk up the road with him but he had no takers, although a tailor who was leaving at the same time said he was going part of the way. As they were passing the recently built St Michael's Church he started to feel more than a little woozy. Before the tailor left up the side road, he advised Mr Cannicott to lean against the bank that surrounded the church, but in fact he lay down and fell asleep on his right side.

After a while he was roused by a hand feeling in his left pocket and a person caught hold of his left hand and pulled and bit at the rings that he had on his little finger. It was so painful he fainted for a moment. He struggled to his feet at last and was going towards home when someone came from behind, held on to his right shoulder and began to rifle his right-hand pocket, which had not been touched because he was lying on it. Altogether he was robbed of two half sovereigns, three rings, a pair of spectacles, two handkerchiefs and five shillings in silver. After all this he managed to stagger home and his daughter said she let him in at 2.20 a.m., his hand covered with blood and a finger hanging

The Horfield Inn was renamed in the twentieth century.

St Michael's Church, built in 1862 and demolished in 1997.

loosely. He subsequently had this finger amputated at the Infirmary later in the morning.

Suspicion fell on Ackroyd Lister and Michael Delaney, two young privates in the 12th Regiment of Foot stationed at the barracks up the road. The soldier on guard at the gate said that Lister and Delaney came in together at about 2.45 a.m. Taken to an identification parade at the barracks, Mr Cannicott said Lister definitely was the one who had bitten off his finger. He was not quite so sure about Delaney. In Delaney's box they found a handkerchief which Mr Cannicott said was his, but the soldier said Lister had given that to him after being given it by a lady friend. One of Mr Cannicott's rings had been found in the road between Horfield and the barracks by a labourer named Collier, who on hearing about the robbery handed it in.

Lister and Delaney were taken into custody and in November made their appearance in court. The two prisoners, having no counsel, were allowed to interrogate Mr Cannicott and badgered him to describe their uniforms, which he could not do exactly apart from the fact they had some red on them. Mr Sampson, the magistrate, asked if he had been too intoxicated to resist and he said he became sober fast when his finger was maltreated. After going through the evidence, Mr Sampson summed up saying that the evidence of identity had been given by a drunken man and declared the two soldiers not guilty, 'to the astonishment of the crowded court'.

In the twentieth century, a new method of street robbery evolved. Motor cars gradually became a common sight and they made for a speedy getaway. Women in suburban areas with handbags over their arms were particularly targeted. The car would drive up, the driver lean across and ask for directions and as assistance was being given, the bag would be snatched and the car was gone. Sometimes a knife might be used to cut the strap quickly, though it was rare that any violence took place. The cars used were most often stolen ones, which would be found dumped within a short time, instances being reported in Downend and Redland for example. Police patrol cars came into use by Bristol Constabulary in the 1930s, allowing the police to arrive more quickly at crime scenes and to follow fleeing criminals.

THOSE BEGUILING YOUNG LADIES

At the end of the eighteenth century *Matthews'* Bristol Directory commented, 'The common women are numerous, of all dresses, ranks and prices and nocturnally perambulate as in London.' Fifty years later they were no longer thought of as an attraction but were labelled 'unfortunates' in newspaper reports where they were most often complained of for robbing their clients. Sailors were prime targets as they came on land with their wages and an eagerness to spend it on drinking and entertainment.

In January 1821 the body of James Knight, the master and part-owner of the brig *Sampson*, was found in the Frome at the bottom of Greyhound Court, Lewins Mead. The previous afternoon he had been drinking with his friend called Wills and by late evening they were both very much intoxicated. It was then that they met Elizabeth Phillips and about 11 o'clock went with her to a house in Greyhound Court. There were two other young women there, called Granger and Courtney, and the men drank gin and brandy with them before going up to bed. While Wills and Knight were asleep they were robbed. Wills had just a bit of silver but, searching Knight's pockets, Elizabeth Phillips found ten bank notes. Courtney was then told to wake the men and say her husband was coming home and so they would have to leave.

This did not go down at all well and there was much drunken argument. It was bitterly cold outside and neither man was in a good state but eventually the women got them into the courtyard. Knight kept on banging on the door to get back in and a shivering Wills left him to it. Next morning a hat and some papers were found in the courtyard by a person who said they remembered hearing a splash in the early hours, like stones falling into the water. So the river was dragged and James Knight's body pulled out. There was no real sign of violence, merely a mark that the surgeon at the inquest thought could be from the grappling iron used to drag the body out. As the wall separating the river from the court was only 2 feet high, it was decided he had gone down that way and fallen over. Greyhound Court was described as a 'receptacle for abandoned females' and there was a recommendation that 'if the present inhabitants cannot be weeded out, the wall ought to be raised to cut off communication with the river'.

A case was brought by William Brewer against Sarah Thorne in 1827. Brewer was described as a respectable merchant of the city and Sarah as the wife of an older man. Brewer had first met Sarah some two or three years earlier. He said that he had spoken to her several times and by her 'loose conversation' he did not believe she was a respectable married woman. In October 1826 he saw her in Wine Street and she had told him he had got her into 'a pretty scrape' by passing

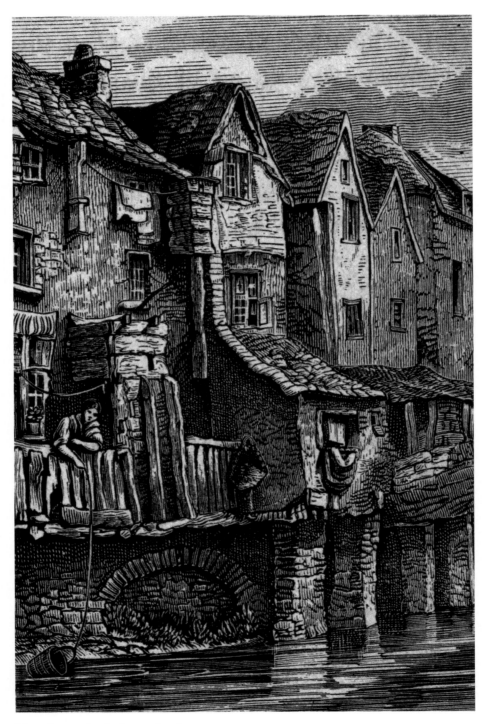

Many houses backed onto the river.

down her street so often, which he denied, remonstrating that he had not spoken to her for six months. Brewer told the court he had never been into a house with her, though he had asked to and she had refused, declaring to him that if she went astray she would be well paid for it. She had told him in the past that her husband was 'an old woman'.

When he had bumped into her in Wine Street she agreed to meet in King Square on a Wednesday evening. This they did and walked together for about half an hour. Then he noticed a man behind a tree, whom Sarah said was probably waiting for his sweetheart, as she persuaded him to just one more turn round the square. That was when the man came up to them and said, 'What business do you have with a married woman?' Sarah said, 'Now, I will leave you together' and went away, while the man brandished a stick and proceeded to beat Brewer with it, managing, when his victim tripped and stumbled, to get in a few really hard blows, bruising him severely.

The man was George Barnard, a wine merchant's clerk, and afterwards he told a friend he had given Brewer a damned good thrashing and made him run and bawl and squall. When questioned as to Barnard's character, witnesses said they considered him a quiet peaceable man. He claimed that he had been asked by Sarah's husband to go with her on that evening to face the man who had spoken to her in the street and caused her insult. Both Sarah and Barnard were found guilty of assault and fined. Interestingly, during the case, the defence counsel had mentioned there would be a cross indictment by Sarah against William Brewer.

King Square.

After the verdict was given, the counsel told the court that 'in consequences of which he was ignorant at the opening', this indictment would not go ahead, which the court officials declared showed 'a sound discretion'.

In 1838 Hannah Dunn was accused of robbing a sailor of a pocketbook at a house in Host Street and was taken into custody when hanging from a window ledge. When she appeared in court she carried a young child in her arms and said she was the wife of a soldier in the 7th Dragoons. He was not currently in Bristol, the regiment being posted to the north of England, so she was supporting herself by prostitution. The magistrates were virtuously horrified at her 'lack of morals', telling her that to adopt such a course of life was a high crime and though she was discharged, they gave her a recommendation to behave better in the future.

With the 1830s had come the construction of railway networks, employing large gangs of itinerant navvies from all over the country. Navvies on the railway

Bringing back an intended victim.

were paid every other Friday and on those days girls were sent out to entice them in to places like Morris's Court in Temple Street. This den of infamy, commented a police inspector, was inhabited wholly by different gangs of thieves and there were upwards of 200 people living there who never went to bed at night. One of the victims was David Hill, a Cornishman who in September 1837 went into Morris's Court in company with a young woman and gave up three shillings for beer, which apparently never arrived. He went to bed putting his clothes with his money in the pockets under his pillow. He had only been in bed for a short time when Robert Tucker and four other men came in and started slapping him. Then Tucker pulled the trousers from under the pillow and Hill snatched them back but others seized them and one took three half crowns from the pocket. Then the men kicked him and beat him. He reported the assault and theft and Tucker was sent to prison for three months.

Once the railway opened, the area near to the station became a fertile hunting ground for the young ladies, helped by the fact that the station was not in the

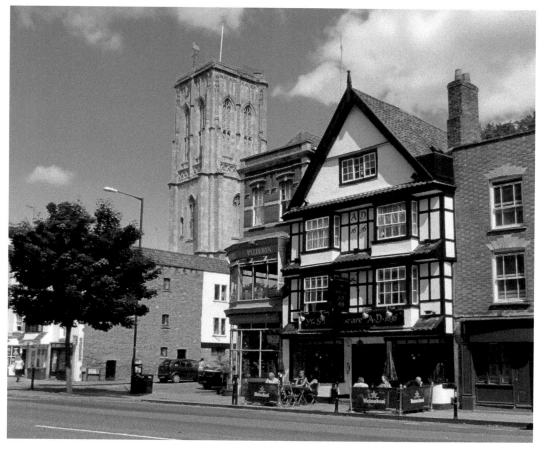

The leaning Temple church and gabled houses.

centre of town and they could offer to give travellers directions and helpfully show the way to their destination. The male travellers often had large amounts of cash about their person and more than a few were prepared to stump up for a drink for a girl with a pretty face. There were a lot of taverns and beerhouses conveniently close by.

In 1848 Ann Fox and her friend asked Michael Murphy, an Irish cattle dealer who was leaving the railway station, to treat them to a drink. He did so in a nearby pub, making the mistake of taking out his purse in full sight of the girls in order to pay. His obviously fat purse contained forty-seven sovereigns, a £10 note and a £5 note. When they left they accompanied him to Portwall Lane, where the other girl went away, and Ann said she would show him a short cut through a broken wall. They were on a piece of rough ground when two men named Thomas Paddock and James Davis caught up with them. Paddock seized Murphy's arms while the others attacked and robbed him and then ran away. When Ann was taken into custody later at her lodgings, she hastily tried to pass five sovereigns to her landlady and, when that failed, in desperation she put the coins in her mouth and tried to swallow them. She managed to swallow one, so a policeman seized her by the throat to make her open her mouth and held it so long that blood ran out of the corners. At the Quarter Sessions Ann, Paddock and Davis received a sentence of twelve months each and presumably Murphy got at least some of his money back.

Pipe Lane, described as three minutes' walk from the railway station, was widely considered to be the haunt of thieves and prostitutes. Several pubs there, including the Carpenter's Arms, the Full Moon, the Britannia, the Rose & Crown and the Sportsman's Arms, had bad reputations, with their landlords described as 'improper persons', some having been convicted. There were other areas that were regularly denounced. Tower Lane was called a sink of iniquity and St James' Back a low neighbourhood with many brothels, while Park Hill in St Michael's became known as a haunt of women with loose morals.

Perhaps one of the largest amounts of money taken was from Daniel Cogan, who had come over from Ireland in the spring of 1847 to sell some sheep, for which he received the sum of £104, and on his way back to his lodgings he went for a drink in the Cornish Mount public house. There he met up with Mary Anne Milford, who was with a couple of other girls and he bought them all a drink. When invited, he went along with them to a house in Host Street kept by Elizabeth Trace, Mary Anne's mother, and had some herrings and beer, which he paid for. Afterwards he and Mary Anne took themselves off to another room and soon he went out like a light, which he ascribed to having been drugged. He was found by a policeman on a pavement and was taken to the police station, where he came round dazed and bemused. But he did remember where the house was and there the police found a little boy who was extremely frightened but eventually said he had seen four women carrying Cogan downstairs and outside. Elizabeth Trace and Mary Anne were taken into custody but unfortunately for

This narrow street just inside the old city walls was full of brothels.

Park Hill.

Cogan, the other women had taken themselves off to London and could not be found, neither could the money, so the case could not be proven. The magistrate said that the Irishman had brought the loss on himself by his own misconduct, so that was that and he went home empty-handed.

In fact the magistrates often gave complainants short shrift when such cases were brought before them. In December 1863 Matilda Page, 'a stout female', was charged with stealing £3 10 shillings from Thomas Shannon, a private in the 31st Regiment of Foot on his way back to Ireland on furlough. It seems he may have been celebrating before he met Matilda and had a glass of beer with her, taking out half a crown to pay and giving her the change. She apparently grabbed the rest of his money from the silk handkerchief he carried it in and ran for it. He did manage to track her down at another beerhouse and gave her into custody but his statement was very garbled and the magistrates found his evidence confused. They reprimanded him for allowing his money to be taken away in that manner and discharged Matilda. Left with nothing to pay for his homeward passage, Shannon asked for help from the court. They advised him to go to the barracks on Hotwell Road and apply there but they considered, 'after he had made himself such a fool with £3 10 shillings in his possession, it would be idle to trust him with funds'.

Five years later, elderly seaman Benjamin Sellick also came in for a telling off. Having accompanied Jane Steele to the Cherry Tree beerhouse in Great Gardens he then went to bed with her and afterwards made a charge that she had stolen three guineas from him plus a silver watch chain, none of which could be found. He was told by the magistrates that he should show more discretion as he was old enough to know better. The loss of his money they said, rather coldly, 'served him right'.

NOT SAFE IN YOUR OWN HOME

Many burglaries were committed on business premises at night, when they were known to be empty and therefore meaning less danger of being caught. For the same reason houses might be broken into when their owners were known routinely to be elsewhere, at market or, on Sundays, at church, but there were times when citizens of Bristol were not even safe in their own home.

Back in 1778, between 9 and 10 o'clock in the evening, Mr Jones, a surgeon in Griffin Lane (now Lower Park Row), opened his house door where someone was knocking only to have a syringe filled with nitric acid squirted at his face. He was lucky as most of it landed on his clothes, which were burned and some splashed on the door and floor. The attacker made off down the lane and escaped pursuit, but next morning there were visible footmarks in front of the door as though they had returned to see what damage they had caused.

Griffin Lane became Lower Park Row with the construction of Perry Road in 1868.

In 1820 a thief, intending to rob a house in Bishop Street later that night, hid under a bed there. As darkness fell, two children came upstairs and got into it, squabbling about who was taking up the most room. Their older brother entered with a candle, ready to tell them off, and the man, thinking the light might reach into his hiding place, moved further into the shadow. One of the boys, feeling the movement beneath him, yelled out in fear. Up leapt the would-be thief and made a rapid escape through the window on to the roof. The shrieks and shouts, thuds, bangs and clatters of the unsuccessful pursuit so scared the pregnant woman who lived next door that she went into premature labour.

Just occasionally it was the criminal himself who suffered from his illegal actions. It was a Sunday morning in August 1822 between 4 and 5 o'clock as Mr Roberts, night constable of Redcliff parish, was going down the lane at the back of Somerset Square, when he saw a man seemingly hiding in an ash pit at the base of a wall. Roberts recognised the man as having been in trouble before and was asking what he was doing when Mr Coalstring, who lived in Somerset Square, looked over from the other side of the wall and told him the man had just been in his cellar. 'And here are his shoes he left behind', he added holding up a

A surviving old house in Bishop Street.

pair. Apparently the burglar had opened a small door into the cellar, let himself down feet foremost, taking off his shoes to get upstairs quietly, but he'd been spotted by a female servant of one of Coalstring's neighbours, so she went to ring the doorbell to alert the household. The man threatened the servant with a broken shovel, if she was thinking to try to stop him, jumped over the wall and broke his leg. He wasn't able to resist arrest.

In 1858 an elderly gentleman named Scott lived at a house in Westbury on Trym with a female relative and servant girl. At half past eight on a Monday evening in late September the lady went to the door to check the weather and in rushed a powerfully built masked man who caught hold of her and forced her back into the kitchen. She screamed and Mr Scott came into the kitchen whereupon the burglar grabbed a candlestick from the mantelpiece, striking Mr Scott repeatedly over the head and face. The lady cried out 'Murder!' and the burglar left as Mr Scott lay bleeding and senseless on the kitchen floor. A neighbour and a policeman heard the shouts for help but didn't work out where they were coming from. So the intruder got to a nearby garden and although

A lane in Westbury.

cornered, he escaped by throwing down his pursuer and scrambling over the garden wall. Mr Scott had tried to fight back by biting one of the man's fingers and the attacker was further injured by the broken glass on the walls, which bore signs of blood. His mask had been torn off and he dropped his sizeable ash wood bludgeon and a screwdriver, but he got away.

On a Saturday night in 1877, two men broke into the home of Mr S. J. James in Priory Road, Tyndalls Park, by wrenching out an iron guard bar from a downstairs window. They ransacked the lower rooms, and next entered the bedroom of Miss Fuller, an elderly relative of Mr James. While one of them seized her by the throat and threatened to murder her if she gave an alarm, the other searched the room, pulling out a gold watch, a gold chain and other jewellery. Pocketing these they left the frightened woman, locking her door on the outside. Mr James, in the adjoining room, had slept through all this but woke when Miss Fuller threw open her window and screamed 'Murder!' and 'Police!' as loudly as she could. Although the police quickly arrived, the burglars had escaped, having jammed open a gate to a neighbouring house before carrying out their raid to allow a speedy exit.

Priory Road.

Violence could occur without there being any intention of robbery. In April 1850 the local newspaper reported the shocking experience of the wife of a respectable farmer living in a large house on the outskirts of Clifton. As they regularly let out parts of the house to visitors to the area, the woman hadn't been surprised when a 'tall stout, well-dressed gentleman wearing coloured spectacles' called one day to make enquiries about the furnished apartments. He was looking for suitable lodgings for himself, his wife, two children and three servants, he said, and she had been recommended by a local clergyman.

She showed him the apartments on the ground floor and he could see she was alone in the house, her husband and servants being down on the farm. He asked to see the bedrooms, though she explained they were the same size as the rooms they had been in already. As he persisted she told him his wife would be the suitable person to check, while he countered that as the father of a family she could be certain there was nothing wrong in it.

It was a grave mistake on her part. She took him upstairs and on entering the bedroom he sprang on her, ripping at her clothes, his nails scratching her shoulder in his haste. She fought back and managed to escape his grasp, rushing for the stairs and hoping to get out of the front door and scream for help. Unfortunately she slipped and fell downwards into the hall as her attacker leaped down and after locking the front door, dragged her into the parlour. By now her dress was in shreds and he tore her undergarments to pieces. He then tied her hands together with his handkerchief, which was when she passed out and knew no more until her husband returned and got help to bring her round, so she could recount the dreadful tale.

Other attacks were carried out at a distance. In November 1819 a pistol was discharged on two successive evenings at the door of a dwelling in Alfred Hill, the balls of which passed through the drawing room shutter as the family were sitting in the room. This naturally caused alarm, but the perpetrator was not discovered. Seven years later the house of Benjamin Porter in Harford Place was targeted, a 'diabolical villain' with a gun firing two bullets, a slug and some small shot from Redcliffe Crescent right across the New Cut. These smashed through the upper panes of the window of the parlour where Mr Porter was sitting, as well as windows on the first floor and the upper storey. It was passed off as an accident, although there was some speculation that this was meant for one of Porter's neighbours, but no one actually said who or gave a reason.

It seems ironic that on the night that Redland Police Station first opened, in January 1892, nearby Trafalgar House in Lower Redland Road, the dwelling of Francis John Carter, a solicitor, was attacked through the use of gunpowder. Mr Carter and his wife Jane had just finished eating supper and their children's governess had left them in the front dining room when suddenly there was a flash accompanied by a tremendous bang, knocking them out of their chairs

Above: Alfred Hill.

Below: Trafalgar House, Lower Redland Road.

and blowing the heavy metal and wooden shutters from the windows, a piece of which struck Mr Carter on the head. Parts of the fire scattered on to the carpet and everywhere was spattered with broken glass.

Mrs Carter, shocked and deafened but seeming physically uninjured, ran to see how the rest of the people in the house had fared. The servants in the kitchen were sprawled on the floor and her two children had been thrown out of bed by the explosion, though had suffered no harm other than fright. The noise had been heard all over the neighbourhood and the cause of the alarming event was found by the dining room window where a can containing the explosive had been placed on the sill with the end of the fuse about 50 feet down the garden. Mr Carter and his wife had been lucky, as the force had been directed outwards.

Several hundreds of pounds of damage was done but in spite of all efforts, including a £200 reward offered, no culprit was found. Jane Carter sadly died in June of inflammation of the lungs. Some three years later, after Francis Carter had remarried and moved to Torquay, joining his brother's law firm, he received a letter which had been sent to his old Bristol office in Broad Street. Constructed in the best anonymous note fashion from letters cut from newspaper (even including commas and parentheses), it stated it was from the person who had caused the explosion, which had 'produced an even stronger effect than expected'. The postmark was Newport, Monmouthshire. A few weeks after, a similar letter was sent to the *South Wales Argus* mentioning that the tin used to hold the explosive had been a round petroleum can of bright tin with conical top and spout and handle. Three other similar letters were subsequently sent. Mr Carter said he had no idea who the malicious person had been but thought it might either be a dangerous lunatic or an aggrieved socialist. He died in 1912 with the mystery still not solved.

There was a time, when you died, you were not even safe in your grave, as Bristol had its resurrection men. On a night in October 1822 two men, one carrying a sack on his back, arrived at a greengrocer's shop in Lower College Street, just round the corner from the churchyard of St Augustine the Less. The shop shared a street entrance with the separately let rooms upstairs. The woman at the greengrocer's had a fair idea of what went on up there: the dissection of bodies as practice for surgeons. So she was pretty sure what the sack contained and she tried to stop the men going in but they managed to push past. She didn't keep quiet about it, alerting her neighbours, and a crowd started to gather. One of them was a man whose recently dead wife had been buried in the churchyard. He hurried away to check her grave. To his horror he saw that it had been disturbed and the body was missing. He went back to the dissecting rooms and taking a ladder, got in through one of the windows and there was the sack containing his wife's body. The surgeon was pursued from the premises by an angry mob and barely escaped with his life, while the man reclaimed his wife's body for reburial.

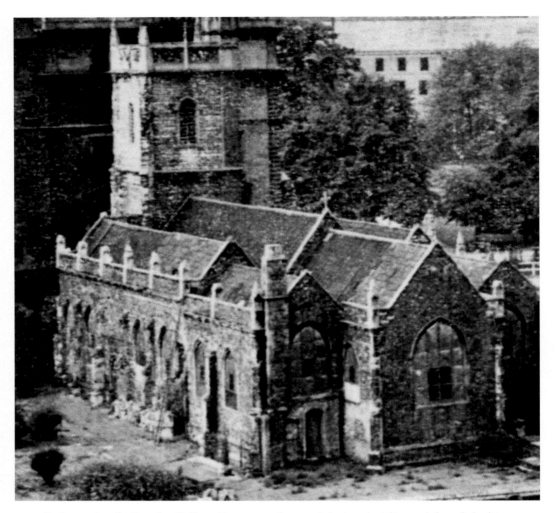

St Augustine the Less by College Green was damaged during the Blitz and demolished in 1952.

DID SHE JUMP OR WAS SHE PUSHED?

John Skinner, a nailer, and his wife, Sarah, lived in an upstairs room at No. 4 Limekiln Lane with their two young children. At about half past seven on a June evening in 1847 her brother James Irwin, a labourer who lived nearby, went to visit. John Skinner was not in the best of moods. He was in bed half undressed, complaining his bowels were playing him up and James recommended castor oil. While he was talking, he was checking out his sister. He was already a bit worried about her as he had been round yesterday evening and he had noticed she was moving stiffly. Although Sarah quickly said she had merely fallen from a ladder, by her sideways glance towards her husband, he could tell this was not true.

Limekiln Lane was renamed St George's Road in 1862. These are some of the old houses that remain.

This evening, while she was making a cup of tea, he saw bruising on her arms and the hearth brush was lying broken on the floor. He asked how that had happened and John actually stated he had beaten his wife with it.

James then, perhaps unwisely, made the suggestion that it was a shame if married people quarrelled and surely it would be better to go their separate ways rather than stay together and have rows all the time. John snapped back: how did he know whose fault the quarrels were and for some people it was their way of life. When James said it wasn't the way of his family, John ordered him out of the room. Sarah then burst into tears, clinging to her brother and begging him not to go, protesting that she would be murdered. John began violently trying to force his brother-in-law through the door but couldn't break Sarah's grip. With all the tugging and pushing, they overbalanced into a tangled heap.

Sarah Skinner was a frightened woman.

While James was struggling to his feet, John managed to jump up and grab a knife from a cupboard and ran towards his wife and her brother, managing to drive him through the door and down a few stairs, then jumped back inside the room. As James stood there on the staircase below, getting his breath back, he heard a loud crash, which he thought must have been breaking crockery. He wasn't sure what to do, but decided to at least get out of the building and let things calm down. Imagine his horror when he exited the front door and saw his sister lying in the road in front of him with a crowd of people around her. He didn't waste any time looking, but made his way swiftly to the police station to report what had happened.

William Watkins, a coach painter, was on his way home from work when he was shocked by the sight of a body plummeting through the air and landing on the ground before him. He looked up to see where she had come from and he saw a window being closed on the second floor of No. 4. As he lifted Sarah's head and shoulders up, William was joined by some women, who brought water in the hope they could help but she was limp and unconscious. At this moment Walter Northcott, an off-duty policeman who lived a few doors away, came running from his house to investigate. He sent someone for a doctor while with Watkins' help he carried Sarah into the lower room at No. 4, but the doctor could do nothing save declare her dead. After achieving authority by fetching his uniform jacket, PC Northcott went up to the Skinners' room where John was calmly lying on the bed, while nearby were the two children.

Northcott asked if John realised his wife had fallen from the window to the street outside and did he know what had happened. His reply was that he saw the hair of his wife's head disappearing through the window. He told the policeman how they had been quarrelling. He had then had a fierce argument with his brother-in-law and forced him out of the room. John asked where his wife was now and on being told she was in the kitchen downstairs, quite dead, Northcott said this was met with a brief smile, a shrug of the shoulders and then silence. PC Northcott saw no sign of a knife near John, but he took him into custody.

In spite of numerous witnesses it was not a simple case. At the inquest the next day a witness called Waters stated that Sarah came out backwards through the window and turned as she fell, her feet striking against a pane of glass in the window below. A seven-year-old boy called Daniel Clancy, who slept on the landing outside the Skinners' room, said that he had been watching through the door while Sarah opened the window and dropped from it before Skinner returned after ejecting Irwin. There were questions about the window, which was nine-paned and approximately a yard square. It was only about a foot from the floor, hinged at the side, opening inwards with a button fastening. James Irwin said it was shut when he was in the room. Caroline Allen, who was down in the street, said that she saw the hand of a man wearing a white shirt close it while Sarah's body was being carried into the house. PC Northcott said it was shut when he went into the room, though a pane was broken but he saw no shards of

glass. Daniel said he saw Skinner close and fasten it when he went back into the room before lying on the bed.

The coroner was wary of Daniel's evidence as he didn't feel it could be given on oath due to his young age. On the other hand the way Skinner had acted was suspicious, seemingly unconcerned about events when the policeman went to see him. Nine of the jury were sure it was murder and three not so persuaded, but the coroner gave a verdict of wilful murder from this and so Skinner was sent for trial at the Crown Court, to be held at Gloucester.

John was described as pale and weak looking at his six-hour trial before Mr Justice Erle. This time young Daniel's evidence took centre stage. He said he got out of bed when he heard all the shouting and stood on a chair. He stated he saw Sarah catch hold of the top of the window and throw herself out backwards as Skinner was re-entering the room, at which the man closed the window and got back into bed. This evidence was no doubt what caused the jury to deliver a verdict of not guilty, despite the prosecuting counsel stressing the fact that Sarah had been terrified of the violence that John could well inflict on her. The result greatly surprised those in the court.

The case was reported countrywide, often criticising the verdict. There were outraged comments in a radical newspaper called the *Political Examiner*, beginning with, 'There are ways of getting rid of a wife with perfect immunity, by driving her to self-destruction by excess of terror.' The 'Inhuman indifference' of shutting and fastening the window and lying down and the 'cold-blooded brutality' of driving her to destroy herself were condemned. The *Lady's Newspaper* also complained, under a headline of 'Protection given to murderers', citing the case as showing prejudice against 'acknowledging the just rights of the feminine sex'.

'THE TERRIBLE RESULTS ACCRUING FROM OVER-INDULGENCE IN INTOXICATING LIQUORS'

That was how the Chairman of the 21st Annual Meeting of the Bristol Auxiliary of the United Kingdom Alliance, a temperance organisation, referred to three Bristol murders that occurred during a mere eighteen months. The first was carried out by William Hole. He was born in Minehead and his father had been bosun of man of war *Bellopheron*, the British ship to which Napoleon surrendered. When William was young the family moved to Bristol and lived in Pile Street. He never learned to read and write, but he was a strong young fellow and became a corn porter on the quays, marrying his wife Alice at the age of eighteen.

He progressed to become captain of the Pickford barges used in the Floating Harbour and also for a while was landlord of the Castle of Comfort in Tower Street, off Temple Back. Things seemed to go well for him and his son went to work in the Pickford office, but then sadly died in an accident when he was seventeen. The lad was riding in a cart loaded with sugar barrels going over Bristol Bridge when one of the wheels slipped into the gutter and the jolt threw him underneath the cart. The lower crank axle crushed him, causing fearful internal injuries, and the boy died. William had taken up total abstinence and he and his wife joined the Baptist church at Counterslip. It didn't last, their pledges were broken, and they were excluded for drunkenness. He was also accused by the church of immorality as for a while he apparently had a mistress in another part of Bristol, who gave birth to at least one illegitimate child.

At 11 o'clock on the evening of 28 August 1874 Alice, rather the worse for drink, was out on the doorstep of their house in Tower Street, which was opposite the Castle of Comfort. Standing in her own doorway, Henrietta Dodge, a neighbour, seeing William Hole come up the street, could tell that he too had been drinking, although he was walking straight enough. He asked how Henrietta was and she replied she was quite well, watching as Alice got unsteadily to her feet and entered the house, followed by her husband. Henrietta decided it was time for bed and was about to shut the door when Alice came out again and went to stand at the edge of the pavement.

As Henrietta looked on, William rushed up to his wife and without a word being spoken, knocked her down into the gutter. He then returned home, slammed the door and locked it as Alice shouted that he was 'an old blackguard'. Alice crawled to a nearby doorstep and rested on it for a couple of minutes, then struggled to her own house. William must have been looking out of the window

William Hole saw his wife on the doorstep.

because he opened the door and asked her to come in but she refused, so he shut it again. Alice, seeing Henrietta there, went to stand by her, muttering. Once more William came out and asked Alice to come in, to which she replied, 'I shan't come in tonight', so back he went and the door was locked again.

Henrietta was still there with Alice by her side when William came out a few minutes later, but this time, as he walked towards them, he had something under his arm. Alice moved away then, into the road, so she could get to the other side. Henrietta realised he was carrying a large carving knife and, badly frightened, she slipped inside her open door and shut it, so she did not see what actually happened next. Even when she heard a cry of 'Murder!' she stayed in the house while she wondered what to do. George Perry, who was in a nearby yard, looked out and saw Alice sitting in the middle of the road. William was leaning over her. He straightened up, threw a knife away, then picked it up again. George went to find a policeman.

Jane Morrish, another neighbour, also heard the screams but she actually ran out to Alice, saw her supporting her head with her hands and confronted William, telling him his wife was dying and asking him to let them bring her into

the house. He said he didn't want that. 'I have killed her and I shall be hung,' he declared. Jane went back to Alice and found another female neighbour trying to staunch the blood with a towel provided by Henry Merchant, the landlord of the Castle of Comfort. He had also heard the screams and seen William leaving his wounded wife. He knew both the Holes well and had noticed their intoxication getting much worse lately. The two women managed to get Alice into the parlour and placed her on the hearthrug, holding her as she died.

When taken by the police William told them quite clearly that he had cut her throat. 'It is all through a drunken wife,' he said. 'This has been anticipated for the last eight months.' He said to visitors when he was in prison that he did it in a moment with no thought of what he was doing. He was sentenced to death in April 1875. Several of the witnesses had told in his trial how he had threatened to commit suicide several times over the previous few years, but the judge considered that there was nothing in the evidence to show he was not responsible for the murder 'by reason of any unsoundness of your mind'. Others did not feel the same way. Petitions for clemency were presented to the Home Secretary with accompanying letters, one from the Bristol MPs Samuel Morley and Kirkman Hodgson and another from Samuel Plimsoll. They were unsuccessful.

At his execution inside the prison grounds, there were a few invited witnesses as well as those attending for legal reasons. A journalist wrote that 'there was a soft mist floating with occasional sunshine. The noose dangled in the breeze above a well in the lawn about 8 feet deep and 7 feet long and 5 feet wide'.

He added that Hole died without a struggle. Then the crowd outside the walls were shown that the execution had been carried out by the hoisting of a black flag.

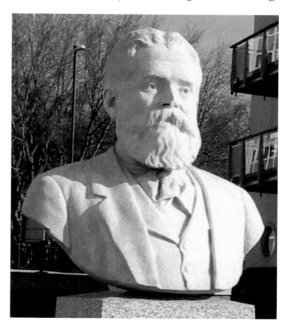

Bust of Samuel Plimsoll on Capricorn Quay.

Above: Gateway to the 'New' Gaol on Cumberland Road, which was in use from 1820 to 1883.

Left: The black flag was displayed above this gateway.

Catherine Cahill had already been married twice when Philip Morris took her as his wife in 1871. Having served in the Royal Artillery for nearly twenty-five years, Philip had two medals and four good conduct badges to his name and had been discharged, at the age of forty-five, with a pension the year before. Now he worked as a Customs House officer. As Catherine did tailoring at home, they should not have been short of a penny. The truth was they lived in a single room, 12 feet by 14 feet, in a far from salubrious house on Narrow Quay 'in a state of dirt and misery', and most of their money went on alcohol. When the wages were spent, Catherine pawned many of their belongings, including his medals and even clothes neighbours were paying her to alter for them.

With them lived Catherine's son, ten-year-old Michael Cahill. They may have been all together in one room but he did at least have a separate bed. At 7 a.m. on Monday 5 August 1875 Catherine went out to buy half a pint of whisky. Philip and Catherine drank it together in bed. She went out twice more, before 9 a.m., buying a half pint each time. It obviously wasn't enough for they then sent young Michael out to purchase a noggin, after which the boy went off to play outside.

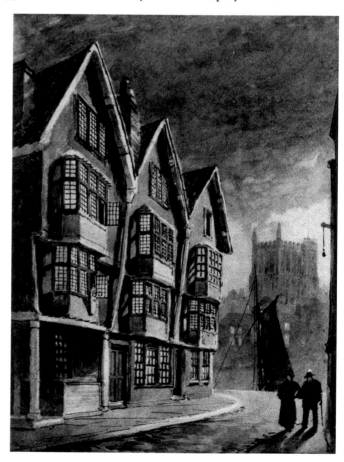

Currant Lane ran from Prince Street to Narrow Quay, where a boat can be seen in this drawing. The houses were demolished and the area covered by the CWS building in 1906, itself replaced by Broad Quay House.

Sometime after this eleven-year-old Mary Ann Lamb, stepdaughter of the man who owned the Narrow Quay house, knocked on the door of their room. She had been sent to collect the rent. Philip called out for her to come in, where she found them in bed, although Catherine Morris was dressed. Mary Ann asked for the rent and Philip questioned as to how much was owed. On being told it was for four months, the girl could see that he seemed astonished. He asked Catherine what made her owe so much and she retorted what made him owe it. He got very angry at his wife, then said to Mary Ann that they were drunk and in bed but he would pay something on the 25th and she left.

All this was overheard, more or less, by Sarah Beckhell, who lived in the room directly above, and she also heard the sound of wrangling that occurred afterwards, though not the exact words, she admitted. Then through the window she saw Morris go off down the lane, coming back about five minutes afterwards, but once he got in the room she heard nothing at all. Elizabeth Price had a room on the same floor as the Morrises, directly opposite, and when her door and theirs were open, she could look straight in. She had gone out about 9.30 that morning and when she returned later she met Philip on the stairs, so he stood back on the landing for her to pass and she went into her room, leaving the door open. He came back in a few minutes and went into his room, closing the door. He only stayed about five minutes, during which she also heard no noise, then he descended the stairs and was gone.

It was Michael, coming home at about 1.30 p.m., who first found Catherine bleeding on the bed, lying on her side, dressed, with a blanket over her. There was blood spattered on the foot of the bed, on Michael's bed, on the floor and patches as large as a man's hand low down on the wall. A couple of chairs had been knocked over and the table pushed to one side. The sleeveboard she used as part of her work, generally kept by the window, was now on Michael's bed.

Sketch of a sleeveboard. Made of wood, this was used in tailoring.

Desperately he tried speaking to her, asking who had done this. Catherine was just about conscious and she muttered something about her doing it and then Philip doing it. Then he ran into Elizabeth Price's room, crying out about his mother being in trouble.

By 1.45 p.m. there was a policeman on the scene. When he asked Catherine to get up, there was no answer. He sent for a cab, took her to the Infirmary and then went in search of Philip, who was nowhere in the house. In the evening Philip was found at his stepsister's house in St Michael's. Hearing what had occurred she asked him, 'Why did you live with that wretch?' To which he replied, 'I told you it would come to this. I told you I would be hanged for her.' On the way to the station the policeman asked why he had stayed with such a woman and he answered, 'How could I get away from the wretch?'.

Catherine lingered, passing in and out of consciousness until the 13th. The four wounds on her head were caused by the sleeveboard, it was decided, a piece of which had been completely broken off. The first blow was no doubt struck

The police tracked down
Morris to his stepsister's house
in the Old Park area.

with great violence, when she was standing up. Philip was 6 foot 2 inches tall, strong and powerful and Catherine's skull was crushed like an eggshell.

At Philip Morris' trial in August the judge drew the jury's attention to this appalling amount of violence and pointed out that though they must consider the provocation that may have occurred, there were faults on both sides. Philip had been given a good character and he had a fine Army record but on the very morning the assault had happened he had been drinking, yet had sent to the Customs House with the excuse that he was ill, so could not work. They jury took seventeen minutes to deliver a verdict of wilful murder, though recommended him to merciful consideration on account of previous good character.

A memorial asking for mitigation of the death sentence was sent to the Home Secretary. The foreman of the jury, Mr Bradshaw, stated that there was a fact that had not come to light in the trial, which would have changed their verdict to manslaughter. This was that Catherine attacked Philip with the sleeveboard first, attested to by a mark on his shoulder. That he had such a previous good character, having served valiantly in the Army, was also stressed. A reprieve to penal servitude for life was dispatched to the gaol, which Philip Morris firstly received with a 'very quiet and proper demeanour' but soon after was reported to become 'utterly prostrate and faint', though he subsequently 're-assumed his wonted quietude of manner'.

In February 1876 Edward Deacon and his wife Amelia lived in Barton Street, opposite Derham's shoe factory. He was a shoemaker but he worked at another factory, Cridland and Rose in nearby Dighton Street. They had married in 1869, when he was twenty-one, though she was twenty-seven, with an illegitimate daughter named Ann Hallett. Edward and Amelia stayed together for a while but then he had spent over five years living away from her and had only come back around the beginning of December 1875.

Amelia had supported herself by making trousers using a sewing machine, helped by Ann, who was now eighteen. Even though her husband was working fairly regularly since returning, Amelia wasn't that happy having him back and they quarrelled a lot. He was drinking quite heavily and could be violent, threatening to kill her with a hatchet in the past, and had broken some of her belongings. He had accused her of being a false, wicked woman mixing with bad company and prostitutes. He was known for being abusive to people living in Barton Street and constantly used foul language.

On 22 February he told next door neighbour Mary Lockstone that he was moving out to go 'on the tramp' and she was pleased. Amelia liked a drink or two, she knew, but she considered her to be a hard-working and industrious woman. That same morning Edward also told his stepdaughter Ann that he was going to leave town and got some of his things together. Amelia was actually out of the house when he left, as she had gone across the road to see a neighbour. When she came back, she and Ann started work on their sewing. Ann went out at approximately half past eleven and when she returned at about 1 o'clock, to

her surprise she found Deacon was back in their house and he and Amelia were quarrelling.

Her mother had completed the work she had been given, so Ann went to get some more from the shop that farmed it out to them. On the way back she met neighbours called Frances Johnstone and Frederick Silvester, who came into the house with her. Deacon had been drinking and said, 'Lucky you came back to save your mother's life.' He tried to kick Amelia and Frances Johnstone intervened, saying he shouldn't treat his wife in that way, so he pushed Frances over, her head striking on Frederick Silvester's knee. Mrs Johnstone left shortly after this and things seemed to calm down, so Ann also went out, Frederick following shortly after. It was about 2.45 p.m. and that was the last time Ann saw her mother alive.

About 4 o'clock on that afternoon Edward knocked on the door of Mary Lockstone, who made her living as a wood chopper, and asked whether both her two hatchets were in use as he wanted to borrow one to chop up some wood to make a bench. She lent him the axe and off he went. A few minutes later she was alarmed by a groaning sound coming from the Deacons' house. Without success she tried to open the closed side door, which was usually left open and so went to the front entrance, which was suddenly opened by Edward.

Long-handled wood chopping axe. (James Taylor)

Mary asked what was going on and what had he done. He told her to go and see for herself, pushed by her and went off down the street. Heart thumping, Mary went inside to the kitchen and slumped into the coal store attached to it she saw Amelia, covered with blood, her head on a heap of coal. She rushed outside screaming that there had been a murder and someone should go for the police. Venturing back to the gruesome sight, she saw the terrible wounds in Amelia's skull and realised to her horror that the weapon used had been her own axe, which lay on the floor.

Jane Coghlan, another neighbour, remembering that only a half hour earlier, while passing the side door, she had overheard Amelia tell Edward, 'Go and may you perish like the stones in the street', was galvanised by the screams, ran to the house and took in the scene. She had just seen Deacon walking off down the street, so followed in his footsteps and caught up with him as he was going towards the Arcade. She grabbed hold of him and accused him of killing his wife and he said, 'I know, I've done it, let me go. I'll give myself up to the police.' Jane said she wouldn't let go of him until he saw a policeman, so holding on to his coat she went with him to the station house, where she told one of the policemen that Amelia Deacon was badly injured and Deacon himself stated that he had killed his wife.

While at the police station Edward showed signs of 'suffering from drink', but was also seemingly ravenous, claiming he had not eaten for some while and his stomach had been upset. He made a statement of his version of events that on the previous day at 7.30 a.m. Amelia began to complain to him, going on and on before he was out of bed and still half asleep. Just a few hours ago Ann and a female neighbour had aggravated him by accusing him in an abusive way. Ann had previously said openly that her mother had the right to turn him out. When Ann and the others had left, Amelia asked him to cut some wood, so he borrowed a hatchet. He was beginning to cut the wood, he said, when suddenly Amelia came at him with the tea kettle. This alarmed him so he hit her on the head with the hatchet. When he realised what he had done, he went to give himself up.

Two policemen arrived at the house, Amelia had her head bound up and was taken to hospital but there was nothing the surgeons could do to save her and she died about an hour afterwards. Two of the wounds had penetrated her brain, injuries caused by swinging the axe with great force. She was buried on 27 February, at Holy Trinity churchyard, St Philip's. Despite the drenching rain the funeral was attended by a crowd of more than 300 people.

At Edward Deacon's trial the jury took only three minutes, without even leaving the box, to pronounce a verdict of wilful murder. Some people afterwards pointed out that his father had killed himself in a temporary fit of insanity some years before, after Edward's mother had been sent to a lunatic asylum so Edward might similarly have been insane when he killed his wife, but nothing came of such remarks. In prison he occupied the same cell as William Hole had before his execution, a year before. Deacon desired to have no visitors but on 22 April he

did see Ann Hallett, bitterly complaining that it was her evidence that had caused a guilty verdict. He was hanged on 24 April 1876, but it was not a swift end. Due to a miscalculation of the drop distance and the stretching of the rope, his feet actually hit solid ground, so he died in agony.

Above left: Amelia Deacon was buried in Holy Trinity churchyard, St Philip's.

Above right: The inside of the remains of the 'New' Gaol gatehouse.

AN INCONVENIENT COST

Elizabeth Jenkins didn't know the woman who knocked at her door around Christmas time in 1872. Living with some of her children in lodgings at James Fuller's Myrtle Cottage, Russell's Fields, she also looked after her baby granddaughter Sarah. Her unmarried daughter Mary Susan, Sarah's mother, had also lived there until recently, but she was now employed as a servant in Cheltenham Road, bringing in some money, which helped provide for the family. Susan had also gone to the magistrates to claim maintenance from Edwin Bailey, whom she had named as the baby's father and under an affiliation order he had been instructed to pay the sum of five shillings a week until little Sarah was sixteen years old.

It was about Susan that the visitor enquired, asking if Elizabeth had a daughter who had a child, as her sister needed a dress made and the mother of the child had been recommended to her. The two of them would come one evening to discuss it, if that was convenient. Pointing to baby Sarah, she asked if that was Elizabeth's daughter's child. She mentioned how much Sarah resembled her baby who had died and was buried at Brighton. Her own name was Anne, she said, and she would definitely come again. That she did and in fact she took to calling in on the Jenkins family quite frequently. She paid great attention to Sarah to whom she was very affectionate, bringing her little treats and speaking often of her own dead child. Elizabeth and Susan both asked if she might know Edwin Bailey, who had a shoe shop in Boyce's Avenue, Clifton. It was there that he seduced the seventeen-year-old Susan, they told her. Anne said she did not know the man and in her opinion, he must be a blackguard.

Anne, a short, thin little woman, as she was later described, always came alone to their house, though they learned that she had a husband called Louis, but she was very vague about any other hard facts and never volunteered her surname. Louis was a porter, she said, but then, another time, described him as a clerk. Their address was not consistent, seeming to vary from Paul Street, Kingsdown, to St James Barton to Thomas Street. When Elizabeth asked about the dress, Anne said her sister had fallen down in Cotham and damaged her spine, was now in the Infirmary and sadly would no longer need the dress.

At the beginning of July Susan took up a job in service in nearby Berkeley Road and Anne tried to persuade her to let her take Sarah and look after her. Susan refused point blank and although she allowed Anne to cuddle and play with the child in Myrtle Cottage, would never permit the woman to go outside with her. One time Susan came in when Anne was visiting and there was mention of ladies who befriended the poor and needy. Susan said there was the possibility that she

Boyce's Avenue, Clifton.

might benefit from this as she was being recommended and was taking some of her mother's chickens' eggs to a lady in Cotham. Anne told her this person was no doubt a member of a Dorcas Society, women who helped those less fortunate than themselves.

In August Susan did receive a letter, the address written on it as 'near the Volunteer beer house', so it was first delivered there and passed on by the landlord. Dated 4 August and signed by a Miss Jane Isabella Smith of Hope Cottage, Cotham, 'the lady visitor of the Cotham Dorcas Society', the letter contained a shilling's worth of stamps and three wrappers labelled Steedman's Soothing Powders. The day after this arrived Anne made another of her visits, asking how Sarah was, and on being told the child was suffering teething pains, recommended the use of powders, saying they were an excellent remedy. This would be the last time Anne came to Myrtle Cottage, as she told Elizabeth that her husband considered the distance from Thomas Street was too great.

Sarah was a generally healthy baby but the teething pains made her fractious. On 17 August Susan made up one of the powders and started to give it to Sarah but from the first the child fought against swallowing it. Thinking it would do good, Susan and her mother forced it down her throat, following it up with a portion of bread soaked in milk. Then Sarah began screaming with her arms out, fists clenching into claws. Terrified, Susan handed the baby to her mother and ran for a doctor. The first two she tried were not available and she had to go as far as the beginning of Stokes Croft where Dr Parsons said he would attend. By the time Susan got back to Myrtle Cottage, Sarah was already dead. Examining the

The envelope contained sachets marked Steedman's Soothing Powders.

body, the doctor was sure Sarah had been poisoned by strychnine and he took a sample of the powders for testing. They turned out to be vermin killer. What was so horrific was that it had been administered in all innocence by the child's own family.

Who had sent the powders to Susan? PC Critchley had carried out enquiries and established that there was no Miss Jane Isabella Smith on the list of Dorcas Society members and no one of that name at Hope Cottage, Cotham or in the neighbourhood. Elizabeth Jenkins put forward the idea that the only person who might have 'had any ill will to the child' was Edwin Bailey, who was made to pay for her upkeep. PC Critchley knew that Bailey found the cost inconvenient. The money was paid to Susan through Critchley and on 16 August, when payment had not been forthcoming for three weeks, he had served a summons on Bailey for the arrears. The fifteen shillings plus the cost of the summons were paid, though Bailey said he would take the matter to a higher court. When Critchley said it had been suggested that Susan would settle for a sum of £100, half the total amount he would eventually pay over the years, Bailey had replied, 'I wouldn't give £5.'

Edwin Bailey had a contemptuously cavalier attitude towards women. Born in Winterbourne, Bailey was himself illegitimate, his mother being a hat maker's daughter and his father apparently a hat clipper at one of the hat factories in the area. Growing up in his grandparents' house, Edwin went to the local National School and at the age of fifteen one of his uncles got him a job at Parry's boot and shoe factory in Downend with hopes of a possible apprenticeship. After a mere week he was dismissed, significantly at the request of Mrs Parry. That was, without doubt, a foretaste of what was to come.

He later got employment at one of Mr Massingham's shoe shops. This shop in Maryleport Street was later sold to Bailey's uncle, Edwin being put in charge of it. After a while he and his uncle quarrelled and he left. He was working in a shoe shop at No. 3 Seymour Place, Stapleton Road, in 1861, lodging next door at the house of John Comer, who owned several properties. On 28 March 1864 Edwin Bailey married Comer's daughter, Hannah, who was five years his senior and whose brother Frederick kept a coffee shop in London and later the Pakenham Hotel in Knightsbridge.

Edwin's next step was to go into partnership with Robert Hayter Chubb in a wholesale business on the Butts. This was so unsuccessful that they were made bankrupt. He then applied to lease premises on St Augustine's Parade, which caused an 'interested party' to contact and warn the building's owner about him. Bailey claimed he was negotiating the lease on behalf of another person, though he was the only one seen at the shop and he paid the rent. During this time there was a fire on the premises, fortunately for the owner not causing a great deal of damage, but he probably was quite relieved when Bailey left and took himself away to London, apparently working as a barman, probably for Frederick Comer.

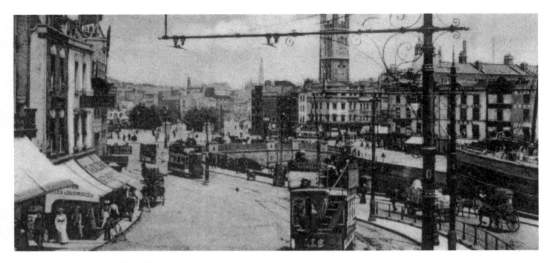

St Augustine's Parade.

Within a year he was back, worked at a succession of boot and shoe shops, being discharged, it is said, for 'acts of misconduct with female assistants', then was off to Gloucester where he was employed by a Mr Jacobs. Here, acting like a single man, he began courting a young shop assistant, unaware that she was the daughter of a Forest of Dean policeman. It was said that some Gloucester policemen, knowing he was in fact married, leaned on him and forced him to scuttle back to Bristol once more. This time he opened a business on Boyce's Avenue and it was here in 1871 that Susan Jenkins, in service at Clifton, brought a pair of shoes to be repaired for her master. 'A female could hardly enter his shop without running risk of molestation on his part' and 'Domestic servants who have taken messages to him from their employers have been known to refuse to again run the risk of encountering him' were two comments made about him.

There was a long drawn-out inquest on Sarah Jenkins, with four adjournments. Bailey did not attend the second adjourned inquest because it was claimed he had gone to see his wife in London, which made the coroner angry and suspicious. He was subsequently arrested as was the woman now named as Mary Anne Barry. When the inquest was resumed once more the solicitors for Bailey and Barry brought up the conflict between evidence that would be given at this and the proceedings of the upcoming magistrates' court, so neither of the two wanted to answer any questions. Bailey said he knew nothing whatever of the poisoning in any shape or form.

There was evidence given by James Atkins, who had worked for Bailey and had been told by him some months before that he was not Sarah's father and Atkins would be handed half a sovereign to give to the first man who could bring evidence of the child's death. When news was brought to Atkins by one of the Jenkins' neighbours late on the evening little Sarah died, he went straight to

Bailey's house and told him that the child was poisoned. Atkins apparently asked Bailey if he had sent any letters and packages, which he denied. Bailey finally wanted to know what poison had been used, which Atkins could not answer so he left and returned home with the money to give to the informant.

At the final adjourned inquest, a statement made by Mary Anne Barry to the police was read telling that she had been sent by Bailey several times to the Jenkins' house merely to find out who the father of the child was and knew nothing about any poisoning. James Atkins once more was questioned and he said that Anne had been employed by Bailey as a charwoman at the shop some while ago and came back to clean during the last year but Atkins never spoke with her and had no idea if she was employed to go on errands.

There was evidence from a handwriting expert of nearly twenty years' experience, M. Chabot, concerning the letter which had accompanied the powders. This was obviously in a disguised hand, he said, of someone trying to mimic a lady's handwriting, but in his opinion definitely that of the same person who had written samples said to be Bailey's. Chabot said his way of working had been to try and disprove similarity. He went into minute and elaborate detail of the make-up of individual letters in the words and the unusual method of writing a shortened version of 'August'. After a long summing up by the coroner, the inquest jury came back with a verdict of wilful murder against Edwin Bailey. On 1 October at Lawford's Gate petty sessions, Bailey and Barry were committed for trial, he charged with murder and she of aiding and abetting in the crime.

By the time the case came to court at Gloucester Assizes in December, much of the detail had already appeared in the newspapers but the court was crowded with those eager to hear everything there was to be told. Bailey, who had previously been described as 'short in stature and of a robust build', apparently looked 'pale, anxious and remarkably thinner than when he was in front of the magistrates', while Barry was attired in black as she had been for all her appearances. There were many witnesses, both to how the letter that had accompanied the powders had gone through the postal system, how the child had reacted to the powder and assertions by medical men that Sarah had died from strychnine. There was also the vital evidence from M. Chabot, the handwriting expert, backed up by PC Critchley, who had received letters from Bailey enclosing payments to Susan Jenkins.

The judge, in summing up, said much of the evidence was of course circumstantial. The point that the jury had to consider was who had sent the powders and the motive and design of that action. There was the fact of the handwriting and there had been no expert proof submitted that it had not been written by Bailey. He reminded them that they had to consider all they had heard and if they thought the letter had been written by Bailey with the intention that the powders should be administered to the child and that the child died as a consequence of that, without any reasonable doubt, then Bailey should be found guilty and this should apply to Anne Barry as well.

The jury indeed had no reasonable doubt, though they did recommend mercy. Bailey, when asked if he had anything to say, maintained it was a conspiracy and that his writing had been forged. The judge, putting on his black cap, told the two prisoners that the deed was carried out with 'great determination and premeditation' and there had been ample opportunity to change direction along the way, before pronouncing the death sentence. The execution was to take place on 12 January 1874.

This was a triple execution as there was also a man named Charles Butt who, having murdered his sweetheart, had received a death sentence at the same assizes. The execution took place inside Gloucester Prison grounds and although some journalists attended, the general public were not admitted. As usual a group gathered outside, in spite of being unable to see anything of the grim activities taking place on that 'bleak, raw and cold' morning. The prisoners were brought out into the yard at just before 8 o'clock, the men in suits and Mary Anne in a white dress with a lilac print pattern, in complete contrast to her usual black. The whole proceedings were short, the drop falling at twelve minutes past the hour.

The chaplain, who had spent much time with Bailey, told the press afterwards that in the end the man had made a full confession of his guilt on the condition that the entire details were never revealed so, as a clergyman, he was keeping that promise. Bailey said he had been an atheist and that had contributed to his actions, but claimed a couple of the witnesses had perjured themselves, adding that Barry had been tempted by money he offered. She was very poor and her husband, Louis Raymond, had been in prison at least twice in recent times. Edwin Bailey maintained to the very end that he was not the father of little Sarah Jenkins.

A FATAL SHOT

Austin and Cross were two soldiers in different world wars and both were tried for murdering their wives. For thirty-two-year-old Private Albert John Cross of the 2/5 Gloucestershire Regiment, the very public deadly act came at 12.55 on the morning of 15 October 1917. He had just completed ten days' leave from France and was waiting on platform five at Temple Meads station for the 3 a.m. train to London, as he had missed an earlier one. With him was his wife, Bessie, but their tenseness was not just due to his leaving; there was a far deeper reason, something he had long been afraid of since he went away to fight in 1915.

Twenty-seven-year-old Bessie was six months pregnant and the child was not Albert's but that of James King, a married man, who as an engine fitter was exempt from military service. She had been meeting him after he finished work. Albert had known how things stood even before he came home on leave. In August he had received a letter from King telling of Bessie's affair with him that had been going on since the previous December and blaming the woman for 'misconduct'. Albert replied to him, accusing him of making a hobby of hunting up women whose husbands were serving their country and signing himself as 'Mr Cross, whose home you have ruined.'

Greetings from France

Postcard showing a First World War soldier in France, where Albert Cross had been serving.

Albert wrote to Bessie on 6 September, beginning, 'Just a line to let you know I am alright, bar upset. Yes, I came through the battle all right and I hope I shall come home safe for the sake of the little boys.' He went on to tell her he had had a 'long letter' from King. 'You are a cruel, lying woman,' he continued, 'and I don't care if I never hear from you again', with threats to have their children taken away from her.

However, in another letter he wrote 'I still love you dearly' and people who met him when he came home on furlough commented that he did not shout or accuse her, but who knows what was said in private. Strange as it may seem, he invited King and his wife to come to see them before he returned to the front, which they did, although Mrs King, who had several children of her own, was said to be 'very much upset'.

So it came time for Albert to get back to his regiment and Bessie accompanied him to the station. They had met an NSPCC inspector to discuss what would happen with the children – perhaps they talked about that or maybe they stood in silence. Suddenly Bessie screamed, 'Oh don't do it!', as a rifle shot rang out. She jerked back, her body twisted and she fell on to a platform truck, shouting, 'I'm hurt!'.

There was no doubt that Albert had fired the fatal shot. A witness, only feet away, saw Bessie raising her arms and Albert, facing her, fingering the trigger, but thought it was being done in fun. Then putting the butt to his waist, the soldier aimed it at Bessie's abdomen and actually pulled the trigger. He made no attempt to go to her, just moved slightly back, rested the butt of the rifle on the floor and stood still. Albert himself told not only a railway employee nearby that he had shot Bessie but also said it to the military police at Temple Meads before any questioning and their examination of his rifle, which had a spent cartridge left in the breech.

Temple Meads station in the early twentieth century.

Bessie, bleeding profusely from the large wound but conscious and begging those around her to look after her babies, was rushed to the General Hospital in a hastily summoned ambulance. They took her to the operating theatre but after a short time the surgeon had to admit that saving her was a vain hope and she died within minutes. Her husband was taken into custody and at the inquest a charge of wilful murder was brought against him. James King did not get off lightly. The jury called his behaviour reprehensible and the coroner ordered him to be put in the witness box before the assembled court, where he told him he was responsible for Bessie's death.

Albert's trial was in November at Bristol Assizes. The prosecution said that all ammunition should have been returned before leaving France and the rifle's safety lever had not been pushed down as it should be and drew attention to the varying moods shown by his letters. The defence countered that there had been proof given that Albert Cross forgave his wife and that the bullet could have been accidentally left in the rifle, as had happened in other cases.

The judge in his summing up showed sympathy for the accused prisoner and even directed that as he was a soldier, 'the jury must not apply to the prisoner … quite the same rule as they would be justified in doing if he were an ordinary individual'. An hour and a half later the verdict came back 'not guilty', to a round of applause, and Albert John Cross was free to leave.

Frederick James Austin, RASC driver, was on embarkation leave when he shot his young wife, Lilian Dorothy Pax, on 31 January 1942 at a house in Montrose Avenue, Redland, where they and their young son were currently lodging in an attic room. Since their marriage in 1937 things had not gone smoothly between them. One of their two children died and at a certain point Lilian had obtained a separation order, but within a week they were back together.

Magistrates' court and police station, Nelson Street.

The house in Montrose Avenue, showing the windows of the attic flat.

In 1941, whilst stationed at Godalming, Frederick had become friendly with a girl called Marion Hendy, whom he had told that he was single. Lilian realised this and confronted them in a distressed state, outside a cinema. At this point Marion was told that he was married and said to Frederick that they should not see each other again. While he was in hospital that October, however, she wrote a letter to him and he not only replied, but kept her letter, which ended 'Love and kisses from Marion'. Lilian found it in a pair of his trousers at the end of January.

According to Frederick, Lilian became angry and when she left the room he put a round of ammunition into his rifle, although he had not officially been issued with any. On her return he told her that the rifle was loaded, just to scare her a little, and asked her to forget the problems they had had, so they could be happy together. He said that she told him not to be silly, to put the rifle down, which he did, then they kissed and made up. His claim was that he never had any intention of harming her, in any case.

Three days later, Saturday 31st, was the last one of his leave. For what actually happened in that attic room we have only Frederick's version of events. After tea he cleared the table as he thought he should clean his rifle there, ready for his return to duty. Lilian sat on a stool near the fireplace, darning stockings. What is certain is that about 5.30 p.m. there was the sound of a shot, which brought the

landlady, Mrs Leat, out of her ground floor kitchen, rushing to the bottom of the stairs in alarm.

Frederick said in his statement to the police and later in court that he had completely forgotten that the rifle was loaded. He pushed the safety catch forward and when he did that he intended to take the bolt out. Then as he was rubbing the rifle with a cloth, Lilian brought up the subject of the letter, asked what he had done with it, saying 'It will be a good job when you do go back.' She had decided to write and tell Marion 'what I think of her', but Frederick told her not to, whereupon his wife bent down, as he thought, to pick up the poker and suddenly the rifle went off in his hands.

Frederick ran downstairs, saw Mrs Leat and implored the landlady to get a doctor quickly as he had shot Lilian while cleaning his gun. She asked why he hadn't activated the safety catch and he told her he had not realised it was loaded. Dr Logan was called and went up with Frederick to the attic, where Lilian lay on her side near the fireplace, her head turned towards the window. Death would have been almost instantaneous, the bullet having passed through her heart and one lung, the doctor declared.

At his trial at Winchester Assizes for murder, to which he entered a plea of not guilty, an expert witness gave the opinion that the gun had been fired at shoulder height, otherwise the bullet would have hit the table. It took the jury two and a half hours to find him guilty of the charge. He made an appeal that at least it should be considered manslaughter. This was dismissed by the Court of Criminal Appeal. He was hanged at Horfield Gaol on 30 April 1942. A completely different result from the case of Albert Cross, twenty-five years before.

Entrance to Horfield Prison.

THEY COVERED IT UP

On Saturday 8 September 1923 Louisa Cooper arrived on Frank Sampson's doorstep, shaking and in floods of tears. He was the managing director of the iron foundry where her husband George was employed as a pattern maker. She poured out a tale of her husband's violent and angry behaviour on Thursday night, of his abusive language and name-calling. How he had smashed china, thrown a kettle and picked up a chair, about to strike her. Fortunately, she said, that was where their son, George Jr, had stepped in. He and his wife also lived in the house with his parents, though they had some rooms for their own separate use. Faced with the younger man, her husband had snatched up his coat, put it on and walked out. He had not come back all these hours later.

Frank Sampson considered that George, his employee since the summer of 1918, had always been exceptionally good at his job and very punctual, worthy of the top wages he earned. Unfortunately his manner was surly; he had a nasty temper, didn't like people expressing different views from his own and refused to admit he ever made a mistake. He remembered George had not been in work on Friday and had thought he was possibly unwell, though he did have another suspicion about the reason for what was happening. This was actually the second time Louisa had been to see Frank Sampson about her husband's behaviour. Some

Sampson's Ironworks stood here.

weeks before she had learned that George was 'carrying on' with Mrs Goodman, employed by the foundry as an office cleaner. The two had been staying behind at the works on a Saturday afternoon. After that visit Sampson had made enquiries, finding out that George was claiming on his time sheet for those extra hours. He had not spoken to George himself but, a couple of days before, Mrs Goodman had been dismissed, which could have prompted George to become angry and go off in a huff.

George Jr also worked at the foundry and when he came in on Monday 10 September, Frank Sampson asked if there was any news of his father. No, came the reply, so Sampson queried whether the police had been notified, seeing as it was now days rather than hours that he had been missing. George agreed he would do that. Sampson thought he was a good pattern maker as well, much more quiet and likeable than his father and said that as his father's tools were still in place, would he like to take over that job, to which he agreed, starting work immediately.

George Sr did not reappear and people such as Henry Poole, the landlord of the house the Coopers lived in, were led to understand that he had gone elsewhere to work. When Poole went to collect the rent on 29 September, Louisa said that her son wanted to have a word and would call on him, which George Jr did a few days later. He said he had found rot, both in the joists of the sitting room which was used by him, his wife and children, as well as in the kitchen and front bay. Poole was quite happy to pay for George to get the timber and carry out the work. The landlord never looked to see what had been done and later paid George seventeen shillings when the tenancy was passed to him.

Sketch of George William Cooper Jr.

The Coopers also had a lodger, a young man called Aubrey Baker. Most evenings he tended to come back from working as a fitter for the tram company, eat his meal on his own in the kitchen and then go straight out dancing, arriving back before midnight and going to bed. Although he had been there almost a year when George disappeared, he had met George very little, as he went to work before Aubrey got up and was generally in bed by the time he came back again. At weekends Aubrey went to watch football or stayed in bed for the day. He did remember Louisa Cooper showing him a bucket full of broken crockery in early September and telling him, 'This is what my husband did when he came home and now I think he has gone off with another woman.' He had never seen George since.

George Jr's wife, who had been staying with relatives since the summer, came back home in November and things carried on with George continuing at the foundry. But the illusion of a 'perfectly normal and respectable household' was about to crumble. It started cracking when George went to see his uncle and aunt, ostensibly to settle a misunderstanding about some dressmaking material his aunt had sent to the Coopers' house. Talk turned to his father and he suddenly said, 'There have been several upsets lately since father has been gone but I know he can't come back, for the simple reason I have put him where he cannot come back.'

His uncle and aunt, unsure what to do, ended up giving him a hot drink and sending him home to bed. Their son, George Blackburn, having overheard, informed his employer, who was an ex-policeman. This was passed on to the police, who next day called at the Coopers' house and told Louisa they wanted to speak to her husband. She said that he had been carrying on with another woman, had left her some time ago and she had had no sight of him after that. The police went away but they came back and waited until 8 o'clock when George Jr arrived home. He was told they were making enquiries about the disappearance of his father, cautioned him and then took a statement.

Now George told an appalling story. According to him, he had come home on 6 September around 8.30 in the evening to find his father there alone, who belligerently asked him, 'Where's your mother?'. On George replying that he did not know, his father said, 'When she comes in I shall upset her.' George then noticed that crockery had been shattered and eggs smashed against the door and walls of the kitchen, while food left for his tea had been dumped in the coal house. George asked his father what was going on and the answer was, 'When your mother comes home, you'll know the reason.'

George said, 'You're not going to touch mother' and his father flared up. He exclaimed that he would bring whoever he wanted into the house, alluding to a woman from South Street he had previously invited there, then picking up a cast iron model of a cow kept by the fireplace, swore at his son and threatened to throw the heavy ornament at his head. He repeated he could have any visitor he liked, that he had more than one string to his bow.

He told his son to get out but he refused, wanting to defend his mother, and the quarrel continued, George Sr saying there could not be two bosses in the house.

He went to throw the cow at his son, who kicked him in the thigh, felling him face forward on to the floor. The older man kept railing, calling Louisa an 'old swine', which prompted his son to threaten to go for him again. The father became agitated, rushed upstairs, then down into the middle room, the front room, the kitchen, through the back door, walking up and down outside the window. When he came back in he sat down in silence for a short while, then put his hat and coat on and went out.

When the older man returned a while later he once again sat in the kitchen, looking at his son through his fingers before he went out to the shed. George Jr had now gone into the middle room and started playing the piano. Suddenly in the mirror, he caught a glimpse of his father coming into the room, shouting, 'Got you' and pulling out a hatchet from inside his waistcoat. There was a violent struggle ending in George Jr wrenching the hatchet from him and delivering as hard a blow as he could on his father's head and as the older man fell, striking him several more times. George admitted the killing but one thing he wanted them to be certain of, it was not with malice aforethought, it was partly in his own defence. He was positive his father was about to murder him.

George seemed confused about what exactly happened next. He said he had wrapped sacking round his father's head and thought he dragged the body to the chicken house, but that it might have been the next night. Anyway he fastened up the room where it had happened with a nail, so no one would go in there. Louisa arrived home at about 10.20 p.m. and asked her son what was the matter. George admitted that there had been a row and things had been smashed up but said his father had then gone out. She went up to bed and a short time later he confessed to having killed his father.

George said that he should then have gone to the police and explained what had happened, 'But all that I knew was that there had been a tragic end to the struggle.' He buried the body a week later in the middle room. He burned the stained carpet and set about refurbishing the room. He bought lime, tar and planks and made no secret of the fact that he was doing work to the house, when people saw him buying and carrying the various materials home.

During the time George was giving his statement to the police his mother had been sent out of the room, but she kept coming in, falling to the floor and

George Jr said his father attacked him with a hatchet from the coal shed.

saying that she had done it and to have mercy on her son. They were both taken into custody. Louisa went to Cardiff Gaol, which had facilities for women, and George to Horfield Prison.

The next day, 31 January 1924, Henry Poole accompanied the police as they entered the sitting room which the younger Coopers used. They removed the furniture and ripped up the new lino and newspaper underlay to expose the boards. The joists had been sawn through in places and parts replaced. Starting with a pick, digging down just in front of the hearthstone 5 feet below the surface, they came upon a layer of lime and tar, underneath which was a body in a decomposed state, the head wrapped in sacking and the rest clothed apart from trousers. There were also spots of blood on the wallpaper near the floor, behind a recently constructed cupboard.

The newspapers printed the 'thrilling story', the 'startling development' of an exhumation and 'astonishing disclosure' revealed at the inquest, complete with many gory details. At the Magistrates' Court hearing a few days later, the public accommodation was packed. On subsequent dates there was much enlightening evidence including that from Alexander Sydenham, who had been the elder George Cooper's workmate and had been in his company until 8.10 p.m. that fatal evening. He described him as a 'nice quiet man' interested in music, although he knew quite a bit about Cooper's dalliances with other women, but had said nothing until pressed in court for information.

On 4 April as the magistrates retired to consider their decision, Louisa completely broke down. She had already been sobbing endlessly during the speech for the defence, though George had remained calm and tried to comfort her. The two Coopers were committed for trial, he upon a charge of wilfully murdering his father, while she was accused of being an accessory after the fact.

The two-day trial was held at Wells Assize Court before Mr Justice Shearman. The various witnesses repeated their testimonies, several telling how they had been informed by Louisa or her son that George had gone away with another woman. Sir Bernard Spilsbury, the Home Office pathologist, gave evidence at the trial, saying that he had found nine blows on the skull, a reconstruction of which was passed round, while he told the court that these had been made by the hatchet. When George was called, he was in the witness box for an hour and three quarters. Louisa was spared that as defence counsel thought she could add little to the case.

The verdict was reached after forty-five minutes. George was found guilty of manslaughter and Louisa of being an accessory. The judge said that he thought the verdict quite correct. He sentenced Louisa immediately and as she had been in prison eight weeks, he thought she had been punished sufficiently as he 'could not be hard on a woman for protecting her own son' and bound her over to be of good behaviour for twelve months. George had to wait a bit longer to hear his sentence. On 1 June the judge pronounced that, 'the injuries sustained by the deceased man were so savage that I cannot treat the matter lightly' and sentenced him to seven years in prison. After serving his sentence George worked as a carpenter and joiner.

HE USED HIS BOOTS, NOT HIS LOAF

In the early hours of 8 August 1947 Joseph Goessens, a gatekeeper at Avonmouth Docks, was cycling home from work when he was flagged down on the Portway by a man who asked his help to push a car, which he said would not start. Goessens obliged and they managed to shift it for 50 yards, but then he got suspicious. The man did not know what make it was or how much petrol was in the tank and Goessens thought it might have been stolen, so he stopped helping, got back on his bike and pedalled off to Brandon Hill police station. Thus the police embarked on a case that the *Daily Mirror* said 'exposed the sordid aspect of Bristol's night life'.

The car in fact was a taxi generally driven by forty-five-year-old William John Herbert Delong, who lived at Luckwell Road in Bedminster. However, Delong was not the man who had asked Joseph Goessens for help. As the police discovered when they arrived on the scene, the taxi driver was dead, his body hanging head downward in the rear seat. Sitting in the front was ship's radio

The most costly new road in the United Kingdom five miles in length, and varying in width from sixty five to one hundred feet, between Hotwells and Avonmouth cost £ 800000.

River Avon & Portway Bristol

Postcard showing The Portway near Bridge Valley Road.

officer Owen Cooney, who was so drunk that it was a wonder he had managed to speak to Goessens at all. The police could hardly get a sensible word out of him and it was only later he told them he had gone drinking at the Mauretania, after which he remembered nothing until he woke up in the stationary cab. He thought the lifeless body was another drunk passed out at the back.

An examination of Delong showed that he had died due to shock from 'multiple injuries distributed mainly over his head, face and neck caused by excessive violence from blunt instruments not excluding hands and feet'.

Although Owen Cooney was still kept in custody as a suspect, it seemed unlikely that he could have carried out such an attack. Delong was described as a thick-set and powerful, muscular man and at the time when he was killed, Cooney would have been in too much of an alcoholic stupor to present a danger.

The police were pretty sure that a violent fight had occurred in the road and that Delong's unconscious body had then been dumped back into the vehicle. A check on the car had revealed that a hidden master switch had been thrown, which cut out the ignition on the car and prevented it being started, doubtless activated by the driver before he got out. The meter registered a fare of 7s 6d. It became vital to discover who his fares were that night. Gradually responses to the call for information began to trickle in.

There were reports that Delong's cab had been seen at Temple Meads incline at 10 p.m., in the Knowle area approximately a quarter of an hour later, while at about 10.30 p.m. he had apparently driven away from a taxi rank outside the Hippodrome with a party of three adults and two children. The attendant at a petrol

The Mauretania in Park Street. The sign was installed in 1938, the first moving neon outdoor one in Bristol. (Misty Morning Photography)

station in Prince Street said he was sure he had called for petrol there at 11 p.m. with two female passengers and another taxi driver stated he had passed the cab on the Portway half an hour after that. There were speculations about the fact that Delong had been wearing a good suit instead of his normal working clothes and regarding the possible contents of an anonymous letter received by the police.

William Delong's funeral was held on 12 August, about fifty taxis following the hearse to the crowded St Dunstan's Church. Days passed with seemingly little progress, although, as came out later, the police were conducting a lot of interviews. On 27 August they announced that they had made an arrest, a twenty-three-year-old Irishman named John Dillon. He had been in the Irish Army and, after being discharged, joined the British Army, serving three years in the Pioneer Corps. As Dillon had been taken into custody, a woman had said to him rather cryptically, 'Mind you use your loaf.' This was Elsie Ellen Bowden, known on the streets of Bristol as Red Ruth.

At the station Dillon apparently announced, 'It is me you are looking for. I am the murderer. I downed him, I knocked him out,' and claimed, 'I belong to the Animal Gang in Dublin and we are a lot of tough boys.' Later he was alleged to have told an officer, 'This is the first murder I have done.' In other interviews he denied what he had said. Ruth, according to the police, when questioned made several conflicting statements.

Dillon had known Ruth for about three months. He had left his wife and children behind in Dublin to come to England to work as a labourer and struck up an acquaintance with Ruth. They 'met under a street lamp in the city centre', one newspaper put it, 'and strolled the streets'. They used to sleep in woods, lorries and parks, although Ruth had given her address in her statements as Grosvenor Road, St Pauls. She had known William Delong for a much longer time and when he saw her, he used to give her a lift. On that night she and Dillon caught his taxi between 10.30 and 11.45 to go to Sea Mills woods and she sat in the back with him, Dillon behind the driver. There was apparently also another woman called Dolores in the vehicle.

Ruth was chief witness for the prosecution, though the jury were warned that she was not likely to command a great deal of credit or respect. She said they got just as far as the tip on the Portway, then Dillon hit Delong on the back of the head with his fist. Delong asked, 'What is the game?' The taxi swerved, Delong pulled up. Dillon had said in a statement that Delong had asked for thirty shillings for the fare but he had no money and although the two women did, they were not prepared to hand it over.

The two men got out and started fighting, the younger man savagely pummelling with his fists. Delong fell and Dillon, who was wearing Wellington boots, violently kicked him in the stomach, so he was laid out in the road. Dillon told Ruth to take the taxi driver's money out of his pocket, and she grabbed £2. They pushed Delong back into the cab, went back to Bristol and slept in the station waiting room.

At the trial before Lord Chief Justice Goddard, Ruth said she had not taken much notice of whether Delong was alive or dead when he was pushed back

into his taxi, just that he was 'out and limp'. There were questions from the defence counsel to the police about how they had obtained statements from Dillon, whether they were volunteered or suggested. The fact that one doctor had reported that the Irishman might be of unsound mind while another insisted he was sane was discussed. The intention of the attack being to rob was an important consideration, a point stressed by the prosecution, whilst the defence contended that no real evidence for this had been shown.

In the end the jury found John Dillon not guilty of murder but guilty of manslaughter. He was sentenced to twelve years of penal servitude. Dillon's wife came to Bristol and was present at the trial. 'A thin childlike woman stumbled weeping from an anteroom at Bristol Assizes' was how her exit from the court was described by the *Daily Mirror*. 'It means that after I have seen him this weekend we shall be parted until he is released', she said to them, telling how she had to return to Ireland and insisted that 'there is no real harm in him'. In 1949 a plea for extension of time to appeal against the sentence, based on the fact that he was illiterate, failed.

The 'five lost hours' of Owen Cooney remained a mystery. In October 1953 whilst serving as First Radio Officer on board the *Aronda* in the Indian Ocean, he disappeared overboard and a search for him failed. At an official enquiry it was reported by his shipmates that he suffered from 'hallucinations and religious fervour'.

Below left: After the war much of central Bristol remained blighted by the bomb damage. John Dillon came to take advantage of the labouring work available.

Below right: The Portway today, showing wooded areas.

WILL WE EVER KNOW?

Few murders are carried out in front of witnesses and we normally have only known the murderer's version of events that took place, apart from a few instances where the victim has managed to make any sort of statement before they died. In some cases the murderer has never been found.

On 21 May 1899 a woman called Ellen Hayball, living in Jones' Court, Avon Street, was discovered lying dead in a welter of blood in her room, dreadfully beaten about the head with a hatchet. Ellen and her children had suffered vicious beatings before from her husband Frederick, a dock labourer, and four of the children had been taken away. Frederick had been imprisoned on several occasions for the assaults, though Ellen had gone back to him from time to time when he was released and had attacked him herself with a knife. Six weeks previous to her death she had again taken out a summons against him.

It was some hours after she was killed that the body was found by Mrs Laura Gilks, who gave the information to the police and, shortly afterwards, saw Hayball in the Cross Guns beerhouse and told him something dreadful had happened and that he should go home. He left the Cross Guns five minutes before the police arrived and seemingly disappeared into thin air, even though the roads around were immediately searched by policemen on bicycles and his description circulated by telephone and telegraph. An inquest returned a verdict of 'wilful murder against Frederick William Hayball'.

A drawing of Frederick Hayball was sent to San Francisco.

Ellen was buried at Redfield Chapel burial ground at the end of May but, despite many rumours, no trace of her husband was found. A report of the crime and drawing of Hayball was printed in the Californian newspapers, as it was thought he may have got on to a boat as a sailor and be heading for America. In 1902 the Cardiff police arrested a man bearing a striking resemblance to Hayball, only to find out they had made an error and two years later a man in custody at Salford claimed to be Hayball but he was proved to be called Harford, having lived in Bristol and knowing the story of the tragedy well.

What happened to the real Frederick Hayball is unknown. The police had a named suspect they searched for yet never found him. There are other Bristol murders that remain unsolved.

In 1940 a window cleaner working at a house in Stapleton Road caught sight of a huddled up body inside the kitchen. Charlotte Roberts was dead from blows to the head, which had been caused by a saucepan and an iron, both bearing bloodstains. A man in a trilby hat seen nearby was never traced and enquiries failed to turn up anyone responsible for what happened. Gertrude O'Leary, who ran an off-licence in Thomas Street was found murdered in her back room in July 1949. Again, a man had been noticed, slim built and down at heel and most likely the owner of a bloodstained cuff discovered torn off at the scene, but there was no arrest.

In the so-called Babes in the Wood murder, seven-year-old June and five-year-old Royston Sheasby had been buried in a shallow grave at Snuff Mills in 1957. There had been an eleven-day search for them. Various leads were followed up over the years but no one has ever been brought to trial. The battered body of twelve-year-old Phillip Green from Sea Mills was discovered on snow-covered Shirehampton Golf Course on 1 April 1970, the boy having failed to return home after collecting lost golf balls. There was the possible clue of a small green plastic purse and pleas for information that produced no satisfactory results. The investigation is still considered active.

These are just four examples that have not been closed. Sometimes with new techniques there comes hope that perhaps the mysteries will be solved. One such act of violence occurred in the hot summer of 1976. Forty-four-year-old Susan Donaghue had trained as a nurse in Northern Ireland and was working as a night sister at Brentry Hospital, which was for psychiatric referred patients, implementing modern treatments and rehabilitation methods. She should have gone on duty on the evening of 4 August but was suffering from a cold and decided to stay in at her basement flat in Downleaze. She rang the hospital to report her absence and a friend came round to have a chat. After her friend had gone, she went to bed, leaving the window of the adjacent room open. It faced on to the Downs and she was no doubt hoping to catch any breeze from the open space.

Susan had a boyfriend, Dennis Foote, who was also employed at Brentry Hospital, although not on the medical side. He was a carpenter and worked with the patients, teaching them useful skills that could aid their rehabilitation. He and Susan were hoping to marry at the end of the year and move into his house. So on the morning

Right: Snuff Mills.

Below: Shirehampton Park Golf Course.

of the 5th when he found out that she had not gone to work the previous evening, he went to see how she was feeling. To his horror she was dead in bed.

Discoveries in the flat included a tobacco tin, a bloodstained pair of size eight string-backed fabric gloves and an old Port of Bristol police truncheon with BD written on it, complete with serial number, but as it was issued before 1947 detectives were unable to trace to whom it had been issued. The truncheon was established as being the weapon used to hit her head seven times. A footprint also showed up on the sill of the partly opened window. She had been sexually assaulted, although the police thought that the initial motive had been robbery.

After a high volume of house to house calls, area searches and the taking of thousands of statements during the following months, there still seemed to be no positive suspects. It became another unsolved murder, reviewed at intervals, but never seeming to move forward. Technology does move on, however, and in August 2016 it was announced that a DNA profile had been established from the evidence. No useful match was found but who knows what the future will bring and there is hope that one day there may be a result. We may never find where Frederick Hayball ended up but there is a chance we will get an answer to who killed Susan Donaghue.

Above left: The windows of Susan Donaghue's flat were at basement level.

Above right: A truncheon was used to attack Susan Donaghue.